SANTA MONICA
1950–2010

IMAGES of America

On the Cover: This 1970s scenic view of the beautiful Pacific Ocean shows the beach and Santa Monica Mountains, with rows of palm trees along both sides of Ocean Avenue, looking north. The Pacific Coast Highway can be seen on the left and a partial view of Santa Monica's buildings and homes is on the right. (Courtesy Santa Monica History Museum.)

IMAGES of America
SANTA MONICA
1950–2010

Louise B. Gabriel
Santa Monica History Museum

Copyright © 2011 by Louise B. Gabriel, Santa Monica History Museum
ISBN 978-0-7385-8143-9

Published by Arcadia Publishing
Charleston, South Carolina

Printed in the United States of America

Library of Congress Control Number: 2010926984

For all general information, please contact Arcadia Publishing:
Telephone 843-853-2070
Fax 843-853-0044
E-mail sales@arcadiapublishing.com
For customer service and orders:
Toll-Free 1-888-313-2665

Visit us on the Internet at www.arcadiapublishing.com

In memory of my late husband, Bob, who cofounded the Santa Monica History Museum with me, and to my daughters, Susan Gabriel Potter and Sharyl Gabriel Szydlik, and son, Robb Gabriel, for their loving support and to the Santa Monica History Museum and its dedicated supporters.

Contents

Acknowledgments		6
Introduction		7
1.	Sightsee by the Sea	9
2.	Dining around Town	23
3.	Luxury Hotels, Churches, Earthquake, Reagan	31
4.	Celebrities and Celebrations	41
5.	Luminaries	55
6.	Santa Monica Groups and Organizations	65
7.	Community Pillars	77
8.	Businesses by the Bay	93
9.	Santa Monica, a Beautiful City	117
Index		126

ACKNOWLEDGMENTS

It has been a great pleasure for me to write *Santa Monica: 1950–2010*. A companion book to my *Early Santa Monica* published in 2009, it completes the story of the growth of Santa Monica and recognizes the businesses, people, community leaders, and volunteers who have helped shape the city along the way and make it one of the most desirable places to live and work.

My thanks to the following sources of useful information: the *Santa Monica Daily Press*; *Santa Monica Mirror*; Marc Wanamaker of Bison Archives; Jim Lunsford, author of *Looking at Santa Monica: the ocean and the sunset, the hills and the clouds*; and those who are written about in the book. Unless otherwise noted, the photographs in this book are from the Santa Monica History Museum's Image Archive. I am grateful for the use of photographs from the museum's collection and to those whose names are credited in the captions of the book. Also, thanks for the photographs from Marc Wanamaker, Bison Archives; Jim Harris, Santa Monica Pier Restoration Corporation; Laurel Rosen, Santa Monica Chamber of Commerce; Diane Margolin, *Santa Monica Star*; Rob Schwicker; Ted Braun; Bruce Smith; Tara Pomposini; Rena McKenzie; and to the museum's photographers, Ho Nguyen and Roger Goodman. My thanks and appreciation go to our museum staff members, Dr. Andrea Engstrom and Ho Nguyen, for their valuable technical help in scanning images and materials, and to the volunteers who assisted—Robert Webster and my personal assistant, Agnes Garcia. Special thanks to Jerry Roberts, Debbie Seracini, Donna Libert, and Tiffany Frary of Arcadia Publishing for their patience, helpful guidance, and support.

INTRODUCTION

Santa Monica is blessed with the glistening of the blue Pacific and the golden sunshine of California. With a delightful year-round climate, it is a place to live and enjoy life and has developed from a resort community into one of the most popular and renowned cities of California. It appeals to the great, the famous, the wealthy, and to the average person. Santa Monica is a playground for old and young, with swimming, tennis, surfing, and fishing. Hundreds of thousands of people swarm throughout the year to its beach and to Santa Monica Pier, which turned 100 years old in 2009.

The city has a rich and colorful history. After World War II, there was rapid major development, including the Los Angeles County Court Building and the Santa Monica Civic Auditorium, which has hosted the Academy Awards and featured performers Ella Fitzgerald, Tony Bennett, Elton John, Bill Cosby, Bob Hope, and countless others. Santa Monica College moved from its original site adjoining the high school to its present location at 1900 Pico Boulevard. Residential construction rose at a rapid race during those years. The Douglas Aircraft Corporation maintained its corporate headquarters here until its merger with the McDonnell Company. Other major firms located in the city, including General Telephone Company, Lear Ziegler, Paper Mate, and Rand Corporation. The era of the 1960s saw continued growth in both residential and commercial construction. In 1965, the Santa Monica Mall on Third Street was closed to vehicular traffic and became a pedestrian mall.

In 1975, the city of Santa Monica celebrated its centennial, and numerous events were held throughout the year. Santa Monica resident May Sutton Bundy, the first American woman to win the Wimbledon tennis championship, rode atop the city and chamber of commerce float, a giant birthday cake, in the Pasadena Tournament of Roses Parade. The centennial was culminated by a gala dinner at the Civic Auditorium with Lawrence A. Welk and his musical family performing. Special medallions were created for the centennial. The Santa Monica Historical Society (now Santa Monica History Museum) was founded under the centennial committee to collect and preserve the history, art, and culture of the Santa Monica Bay area.

The Douglas Plant closed in 1968, depriving Santa Monica of its largest employer. A 1924 round-the-world flight in Douglas planes had put Santa Monica on the map. In 1969, Lawrence Welk built the Champagne Tower, the Lawrence Welk Plaza, and 100 Wilshire, the tallest building in the city. All are located on Ocean Avenue. The Lawrence Welk Band appeared at the Aragon Ballroom in Ocean Park and was so popular it debuted on national television with the Lennon Sisters in 1955. Welk, who lived in Santa Monica, retired in 1982 after 58 years of entertaining.

The Fairmont Miramar Hotel was originally the site of the mansion of Sen. John P. Jones, cofounder of Santa Monica, who entertained many of the nation's leading artists and public figures, including Susan B. Anthony and Mark Twain. Over the years, those who stayed at the Miramar Hotel Bungalows included Eleanor Roosevelt, Charles Lindbergh, and US Supreme Court justice Earl Warren. In 1931, Betty Grable was singing in the hotel bar with a band of

talented musicians. In the 1980s, the grounds were feature locations for such shows as *Dallas*, *Hart to Hart*, and *Knots Landing*.

Santa Monica has become the new film center of the Westside and a center for the entertainment industry. The American Film Market has been held in Santa Monica a number of years. In his movie *Rocky III*, Sylvester Stallone did a running scene on Santa Monica Beach, and Forrest Gump ended his run across America at the Santa Monica Pier. The late-1970s sitcom *Three's Company* and the late-1990s crime drama *Pacific Blues* were set in Santa Monica. Over the years, Santa Monica has attracted many glamorous leading ladies such as Joan Crawford, Barbara Stanwyck, Bette Davis, Kathryn Grayson, Jeanette MacDonald, and Betty Grable, every GI's favorite pinup girl during World War II. Ice-skating star Sonja Henie performed all over the world but always came back to Santa Monica. In 1995, the band Everclear released a song titled "Santa Monica," which became its first mainstream hit.

Since the late 1980s, the city has experienced a boom through the revitalization of its downtown core, with significant job growth and increased tourism and businesses. Famous architect Frank Gehry designed Santa Monica Place, Santa Monica's first shopping mall, which opened in 1980. Celebrity chef Wolfgang Puck opened his second restaurant, Chinois, on Main Street in 1983. The 1990s saw continued development in the city such as Colorado Place, Water Garden, MGM, Sony, and other corporations. Shutters was the first of several luxury hotels built between the pier and Pico Boulevard. One of them, the Loews Santa Monica Beach Hotel, is on the site of the 1800s Arcadia Hotel, the first luxury hotel ever built in Santa Monica. The Casa Del Mar was restored in 1999 after a reported $60-million renovation. In 1994, an old rail station was transformed by the city into Bergamot Station, a collection of galleries that has become a center of art exhibition and retailing. Santa Monica is home to many notable businesses, including video game companies and studios, the Playtone Company, which is headed by actor Tom Hanks and producer Gary Goetzman with branch offices in Santa Monica, as well as Microsoft, Yahoo, Google, Universal, and MTV.

Constructed in 1936 by W.I. Simonson at Sixteenth Street and Wilshire Boulevard, the Packard Building was destroyed by fire in the 1980s and rebuilt to its original style. Between 1950 and 1960, Montana Avenue and Main Street turned from a sleepy community to an upscale business area. In 1992, Hensheys, which opened as Santa Monica's first department store, closed. The 1994 Northridge Earthquake caused the loss of many residences and historical buildings. In 1998, the *Outlook* newspaper, founded in 1875, closed down because of a decline in revenue. There is always something happening on the Third Street promenade, with its kaleidoscope of street performers, artists, vending carts, special events, and outstanding shopping and dining.

Over the years, the Santa Monica History Museum has held community-wide celebrations for milestones in the city's history. In 1990, the museum held a celebration marking the centennial of former resident and comedian Stan Laurel's birthday, which included a look-alike contest and gala dinner. During its 25th anniversary tour in 2010, Cirque du Soleil performed at the Santa Monica Pier. The latest Santa Monica event came in 2010 for the city's 135th birthday.

A generous gift from the Annenberg Foundation made it possible, under a tripartite agreement in 2005 between the city, the state, and the Annenberg Foundation, to preserve actress Marion Davies's estate as a public beach facility. Santa Monica is as popular today as it was when it was founded in 1875.

One
SIGHTSEE BY THE SEA

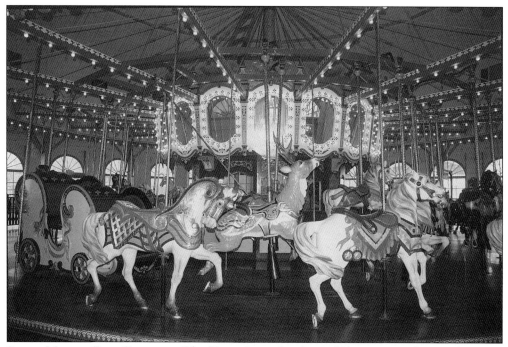

SANTA MONICA PIER CAROUSEL. The Hippodrome has housed three carousels over the years. The first one, installed by Charles Loof in 1916, remained until 1939, when it was replaced by a merry-go-round previously located at the old Pacific Ocean Park Pier. The current carousel was built by the Philadelphia Tobaggan Company in 1922 and was moved from Nashville, Tennessee, to the Santa Monica Pier in 1947. The Hippodrome building was designated a National Historic Landmark in 1988. (Courtesy Cindy Bendat.)

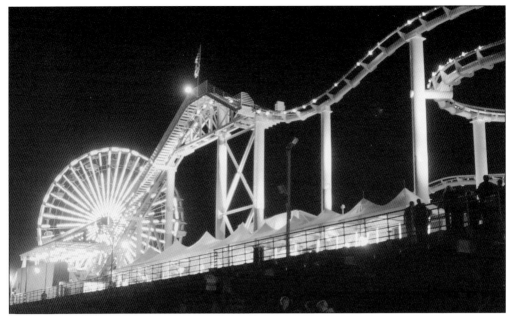

PACIFIC PARK, SANTA MONICA PIER. Since opening in 1996, Pacific Park on the Santa Monica Pier has entertained an estimated 10 million visitors, provided more than 24 million rides on its 12 amusement rides, and awarded more than 1.9 million plush toys at its Pier Pleasure Zone games. The park's Ferris wheel surpassed three million riders. It underwent conversion to solar power in 1998. Mary Ann Powell is chief executive officer and general manager of Pacific Park. (Courtesy Mary Ann Powell.)

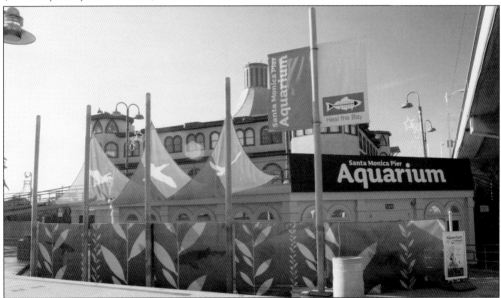

SANTA MONICA PIER AQUARIUM. The aquarium is located beneath the Santa Monica Pier. Since 2003, it has been operated by Heal the Bay. It was formerly known as the Ocean Discovery Center and was operated by UCLA. The aquarium attracts more than 65,000 visitors from around the world each year, among them 15,000 students. Its numerous exhibits feature marine life native to Santa Monica Bay. (Courtesy Jim Harris/Santa Monica Pier Restoration Corporation.)

SANTA MONICA HISTORY MUSEUM TOURS. The museum features a permanent exhibit gallery, a changing exhibit gallery, research library, and gift shop. It is enlightening, inspiring, and offers visitors never-before-seen art, artifacts, and photographs along with many other attractions. The permanent gallery showcases Santa Monica's transformation from humble beginnings as a quaint seaside town in the 1800s to the bustling city of today. Interactive displays include a Douglas DC-3, the *Outlook* newspaper, and Then and Now. Exhibits include the piers, bathing beauties, muscle beach, early film industry, businesses, and original oil paintings. The separate, changing gallery displays personal collections, costumes, the arts, and history-making events. The museum's Morley Builders Santa Monica and California Research Library has an extensive collection of rare books, documents, and records. Free docent-led tours are given to school classrooms. The museum is located at 1350 Seventh Street.

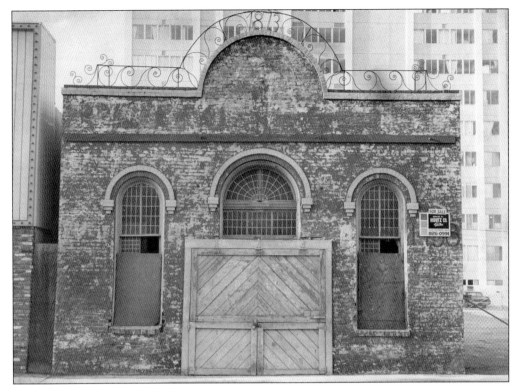

RAPP SALOON. Located at 1428 Second Street, the Rapp Saloon was built in 1875 by William Rapp and is the oldest masonry building in Santa Monica. It was originally a beer garden and was used as the city's first town hall. Today, Hostelling International owns the property. It was saved from demolition by the Santa Monica History Museum over a six-year period following the efforts of mayors Herb Spurgin and Clo Hoover.

SANTA MONICA MUSEUM OF ART. Located in the Bergamot Station Arts Center, the museum was founded in 1984 by Abby Sher. It supports contemporary art through exhibitions and related programs that embrace diverse aesthetic, cultural, and ideological perspectives. The museum offers temporary exhibitions organized by in-house curators and guest curators from around the world. Through its exhibitions and educational and outreach programs, the museum fosters diversity and innovation.

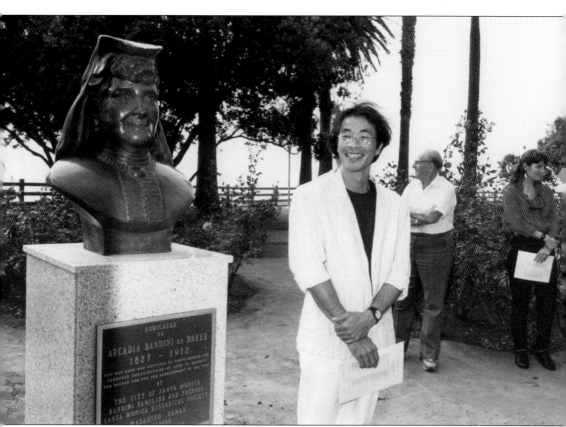

ARCADIA BANDINI DE BAKER MONUMENT. On October 18, 1987, an unveiling and dedication ceremony was held for a monument honoring Arcadia, the wife of Santa Monica's cofounder Col. Robert S. Baker. The monument was sponsored by the Santa Monica History Museum, which initiated the project, Bandini families and friends, and the City of Santa Monica in recognition of Arcadia's generosity in donating the land for Palisades Park, along with Santa Monica cofounder Sen. John P. Jones. The monument, located in the Palisades Park Rose Garden, was sculpted by Masahito Sanae. In 1985, he was commissioned to do the bronze bust.

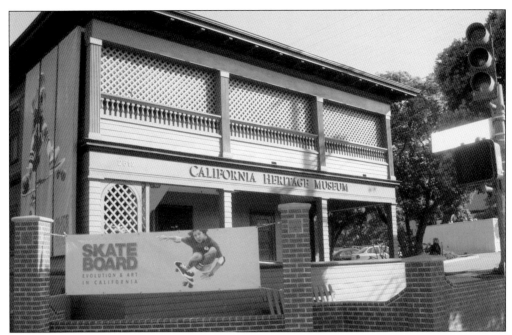

CALIFORNIA HERITAGE MUSEUM. The museum is located at 2612 Main Street in an 1894 Victorian house that was originally the home of Roy Jones, son of Sen. John P. Jones, and later a rooming house in need of renovation. To save the house from demolition, it was moved by the city in 1976 from its original location at 1007 Ocean Avenue to its current one. The museum offers various exhibits and programs.

ANNENBERG COMMUNITY BEACH CLUB. Opened on April 25, 2009, the new beach club was formerly actress Marion Davies's property. It is located at 415 Pacific Coast Highway and features a swimming pool and guesthouse. The property was purchased by the state in 1960. A $27.5-million gift from the Annenberg Foundation and an agreement between the City of Santa Monica, the State of California, and the foundation in February 2005 provided for preservation of the beachfront property as a public facility.

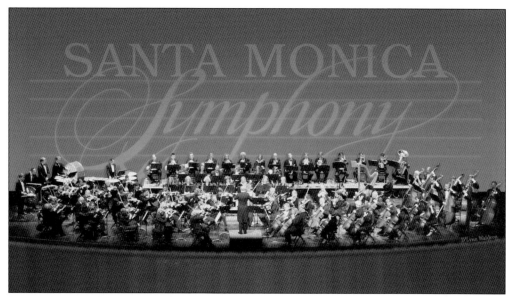

SANTA MONICA SYMPHONY. The symphony has been a major cultural asset for the Southern California Westside Community since its debut in 1945. Each season, the orchestra presents four free concerts at the Civic Auditorium to an audience of 5,000 people of all ages. The symphony has grown to its present excellence under the batons of outstanding conductors/music directors such as Victor Bay, Yehuda Gilad, and Dr. Allen Robert Gross. (Courtesy D'Lynn Waldron.)

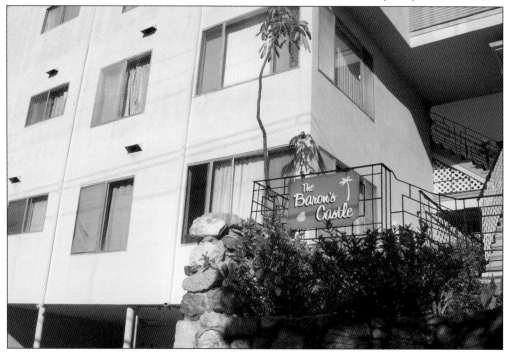

THE BARON'S CASTLE. Located in Ocean Park, the Baron's Castle, a Moorish villa, was designed and erected in 1907 by Nicholas Baida. It has three stories topped by a large dome. In 1920 and 1921, it served as a convalescent home for veterans of World War I. It was eventually acquired by world-renowned wrestler Baron Michel Leone, who gave it the name Baron's Castle. (Courtesy Agnes Garcia.)

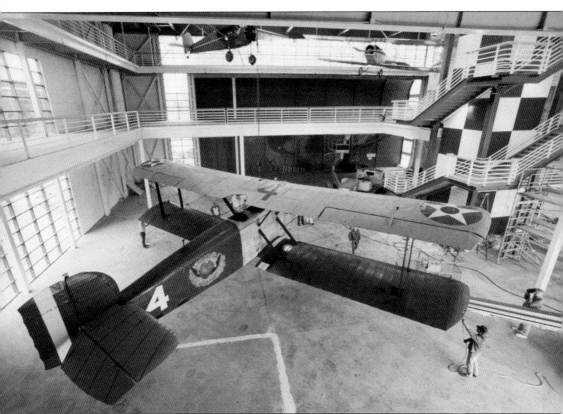

MUSEUM OF FLYING. In 2009, the Museum of Flying announced the establishment of the California Aviation Hall of Fame, which will operate as a nonprofit organization and subsidiary entity to the Museum of Flying. The hall of fame was created in order to recognize and pay tribute to the California visionaries who have made significant contributions to the advancement and development of the aviation and aerospace fields. A special section of the new Museum of Flying will be dedicated to display the hall of fame and inductees along with images, artifacts, and ephemera. The museum at 3100 Airport Avenue at Santa Monica Airport is leased from the city. Donald G. Price is the museum's founder and chairman, and Dan Ryan is the managing director.

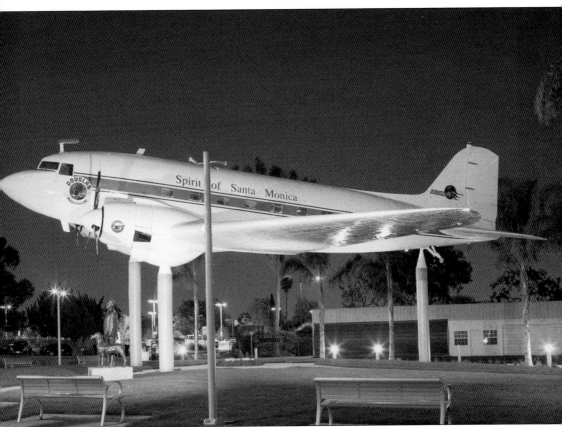

DC-3 Monument. Architect Kristina Andresen designed the DC-3 Monument, a new city park at Santa Monica Airport. It was completed in 2009. The iconic 1942 airplane was manufactured at the world-famous Donald Douglas Aircraft Plant. A generous donation was given by David G. Price toward the rehabilitation of the airplane that he had donated to the city, and hundreds of volunteers spent over 3,000 hours restoring the deteriorated plane. Morley Builders constructed the outstanding project. The Employees' Community Fund of Boeing underwrote the cost of construction as well as a life-size sculpture of Donald Douglas and his dog, Bar, on the site. Morley and Andresen donated services to the effort. The project's dedication was on March 21, 2009. Hundreds of people attended the opening, among them many loyal retirees who had worked for Douglas. (Courtesy Kristina Andresen.)

CIRQUE DU SOLEIL. Beginning as a group of street performers in Quebec in the early 1980s, Cirque du Soleil now has over 4,000 employees from more than 40 different countries, including 1,000 artists. The troupe performed at the Santa Monica Pier in 1987. It returned to the pier in 2009 during its 25th anniversary tour.

SANTA MONICA PLAYHOUSE. The playhouse is a nonprofit educational corporation founded in 1960. It provides exciting and entertaining dramatic and comedic, classic, and contemporary live theatrical productions, family theater musicals, and birthday and tea parties. It also has year-round and summer theater workshops and educational programming for children, teens, and adults. The playhouse is located at 1211 Fourth Street.

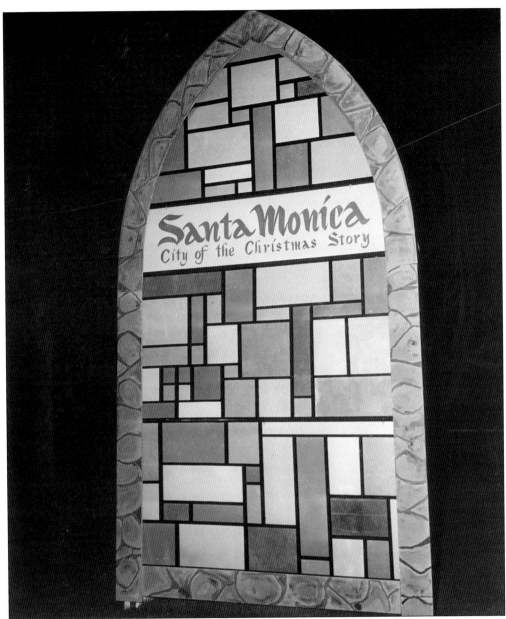

SANTA MONICA NATIVITY SCENES. In 1953, Joan Wilcoxon, an associate producer for Paramount Studios, approached the chamber of commerce manager Herb Spurgin with the idea of city-sponsored nativity scenes in Palisades Park. Spurgin, a tireless community supporter and former mayor, embraced the idea. He set out to gain community support for the event with the help of Ysidro Reyes, another businessman. Spurgin and Reyes rounded up support for the project from churches and businesses. The initial pageant in 1953 opened in the evening with eight scenes illuminated by lights, a procession of choristers, and a float up Wilshire Boulevard. In the late 1950s and the 1960s, the nativity scenes developed into a major attraction. Students from Santa Monica College built a 20-foot-high, freestanding stained glass window proclaiming Santa Monica the "City of the Christmas Story." Bob Gabriel was also a prime supporter of the nativity scenes for many years. (Courtesy Santa Monica Nativity Scenes.)

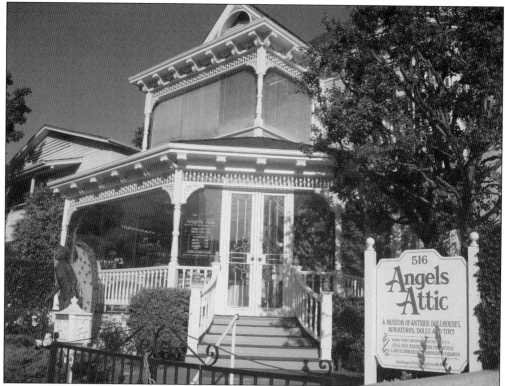

ANGELS ATTIC MUSEUM. Located at 516 Colorado Avenue, Angels Attic Museum was founded in 1984. The Queen Anne Victorian house was built in 1895 and has been restored to that period. Its fascinating doll houses and miniatures, most of them over 100 years old, captivate young and old. The seven galleries and many display cabinets at Angels Attic provide an experience of delight, enchantment, and discovery.

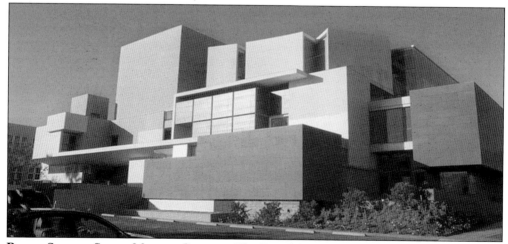

BROAD STAGE—SANTA MONICA COLLEGE. The Broad Stage was named after Eli and Edythe Broad, the philanthropic art-lovers who donated $10 million to launch the project, a 499-seat, state-of-the-art theater at the college, which has hosted an array of classical music concerts, rock shows, and vocalists. There is also an art gallery at the venue that features the work of the college's students and faculty. (Courtesy Santa Monica College.)

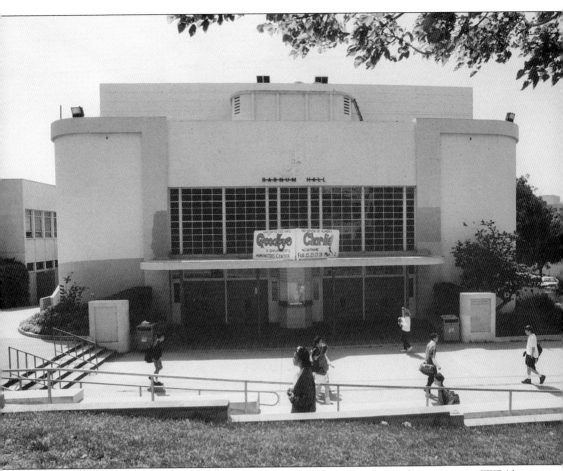

BARNUM HALL. In 1937, Barnum Hall was built by the Works Progress Administration (WPA). It was constructed on the Santa Monica High School campus to be a cultural magnet to support school and community performing arts events. By 1994, Barnum Hall had fallen into disrepair, and the Northridge Earthquake destroyed the original pipe organ. The hall closed in 1997 for restoration. A coalition of citizens, parents, alumni, faculty, and elected officials worked tirelessly for years to generate funds to restore the hall. The volunteer group Restore Barnum Hall, chaired by Jean Sedillos, raised awareness in the community and more than $1 million to restore the venue. The city donated $1.1 million. Santa Monica and Malibu voters approved Proposition X, which also leveraged state bond funds for the renovation. For 15 years, the Samohi Alumni Association kept its newsletter readers updated and handled hundreds of donations. The refurbished Barnum Hall opened in 2002. In 2009, a renovated 1921 Wurlitzer pipe organ, donated by Gordon Belt, was installed in the hall.

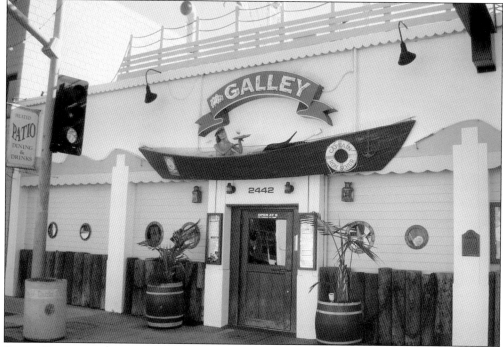

GALLEY RESTAURANT. Located at 2442 Main Street, the Galley is one of the oldest restaurants in Santa Monica. It was founded in 1934. Some of the memorabilia that surrounds the restaurant is from the 1934 movie *Mutiny on the Bounty* with Clark Gable and Charles Laughton, including the steering wheel and boat used in the movie. Eleven framed 1940 war-bond posters are around the Galley.

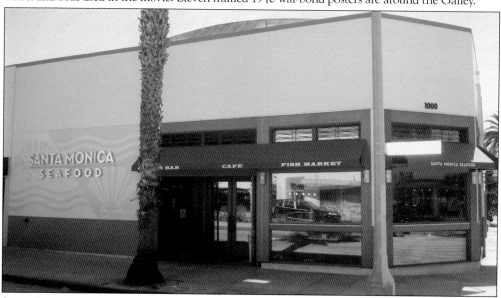

SANTA MONICA SEAFOOD. Santa Monica Seafood is a private, family-owned and -operated company that has been in the business of supplying quality seafood products since it opened on the Santa Monica Pier in 1939. It later moved to Twelfth Street and Colorado Avenue. The company moved its headquarters to Rancho Dominguez in 2003 but continues to maintain a Santa Monica retail store in its newest location at 1000 Wilshire Boulevard.

Two
DINING AROUND TOWN

WOLFGANG PUCK, CHINOIS RESTAURANT. Born in Austria, Puck began his formal chef training at the age of 14, inspired by his mother, who was a hotel chef. He immigrated to the United States around 1973. In Los Angeles, he became both chef and part owner of Ma Maison. In 1983, Puck and his wife, Barbara Lazaroff, opened their second restaurant, Chinois, on Main Street in Santa Monica. Puck's more elaborate menu and Lazaroff's wildly exotic decor earned the restaurant international acclaim. (Courtesy Bella Lantsman/Chinois.)

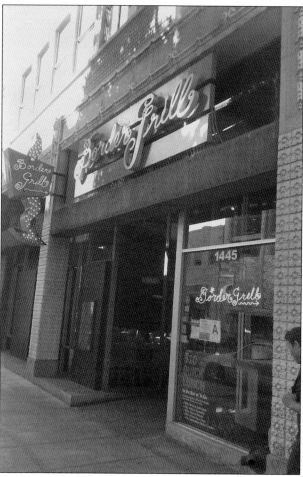

EL CHOLO MEXICAN RESTAURANT. In 1923, Alejandro Borquez and his wife, Rosa, opened the Sonora Café in a small storefront in Los Angeles. In 1925, while a guest was waiting for his dinner, he drew a figure of a man on his menu and called him "El Cholo," the name given to field hands by California's Spanish settlers. Alejandro liked the name and changed Sonora Café to El Cholo. In 1997, El Cholo opened a location in Santa Monica at 1025 Wilshire Boulevard. In 1996, the chain sold its billionth tortilla.

BORDER GRILL. Located at 1445 Fourth Street, the Border Grill is the restaurant of celebrity chefs Mary Sue Milliken and Susan Feniger, who present upscale modern Mexican cooking in a colorful urban cantina. The duo, also famous from Food Network's *Too Hot Tamales*, has established a new standard for gourmet Mexican fare with authentic dishes they learned from home cooks and street vendors on many trips far south of the border.

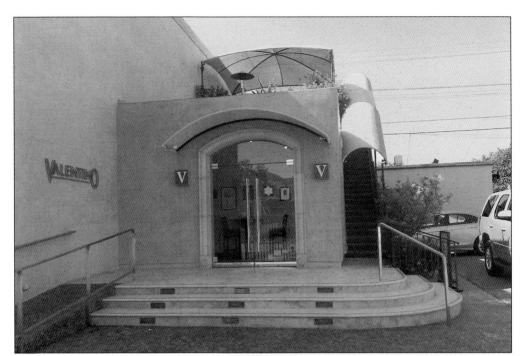

VALENTINO. Located at 3115 Pico Boulevard, Valentino is famous for award-winning wine cellars featuring more than 200,000 Italian, French, and California wines. Piero Selvaggio is owner and operator of the restaurant. He cofounded Valentino but soon bought out his partner and has been sole proprietor for more than 30 years. Selvaggio regularly returns to Italy for new ideas in Italian cuisine. The restaurant has received many accolades, among them several James Beard Awards.

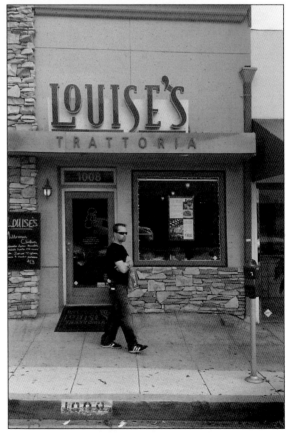

LOUISE'S TRATTORIA. The restaurant has two locations in Santa Monica. The first one opened in 1980 on Twenty-sixth Street and the second one at 1008 Montana Avenue in 1983. The restaurant is known for its great-tasting Italian food. It is a supporter of Santa Monica schools and charitable organizations.

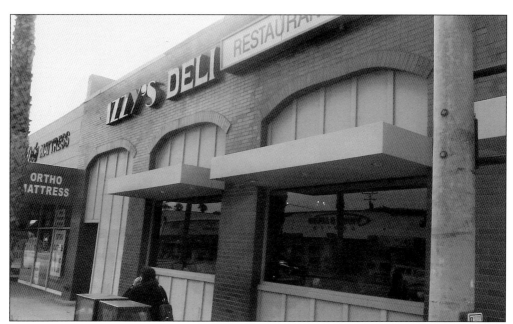

IZZY'S DELI. Raised in Brooklyn, New York, Izzy Freeman, founder of Izzy's Deli, loved eating at a deli when he was a child and dreamed that one day he would own his own deli. In 1953, he moved to Los Angeles with his family. Through his involvement with the City of Hope as a volunteer, he met Ernie Auerbach, a Santa Monica developer. They discussed the idea of opening a deli in Santa Monica, and in 1973, Izzy's Deli opened at 1433 Wilshire Boulevard.

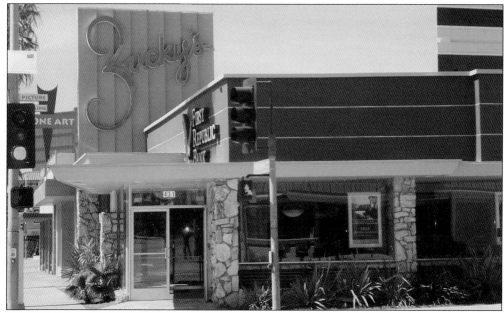

ZUCKY'S DELICATESSEN. The huge Zucky's sign still sits on the building at 431 Wilshire Boulevard that was once the famous delicatessen. Named for Mrs. Altman by her husband, Hy, the restaurant opened in 1954 and was among the biggest and most beautiful social spots in Santa Monica and the first deli in this then sleepy little beach community. With no locks on either the front or the back doors, it was the first all-night coffee shop in town.

THE VICTORIAN. Located at 2624 Main Street, the Victorian is a gourmet restaurant in a restored Victorian house that was formerly located at the corner of Ocean Avenue and Washington Boulevard. It was built around 1900 and once known as the Kyte house. In 1976, the home was moved to its present location along with the adjoining Roy Jones house to form Heritage Square. It was known as the Chronicle Restaurant when it first moved to Heritage Square.

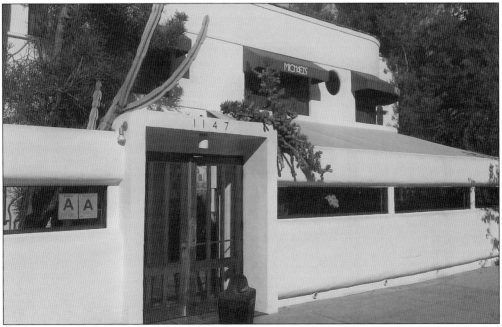

MICHAEL'S RESTAURANT. Michael McCarty opened Michael's restaurant in 1979. He is renowned for developing a classic contemporary cuisine that is constantly evolving with new ideas and ingredients. Selections on the wine list include more than 800 labels. The spacious Garden Room has artworks by Frank Stella, David Hockney, and Robert Graham. Michael and his wife, Kim, are business partners. The restaurant is located at 1147 Third Street.

CHEZ JAY. Located at 1657 Ocean Avenue, the restaurant features peanuts as part of the atmosphere. One of the eatery's peanuts was carried to the moon and back by Apollo astronaut Alan Shephard. Over the bar hangs a 45-pound yellowtail fish caught by George S. Patton Jr., later General Patton, off Catalina Island in 1899, when he was 13 years old.

ENTERPRISE FISH CO. Built in 1917, the historic building now home to the Enterprise Fish Co. restaurant was once a transfer station for the narrow-gauge Red Car line, Los Angeles's first mass-transit system. It was later the repair house for the world-famous Pacific Ocean Park, home to the oldest wooden roller coaster west of the Mississippi. The numerous historical photographs on the walls are from the image archives of the Santa Monica History Museum. The restaurant is located at 174 Kinney Street.

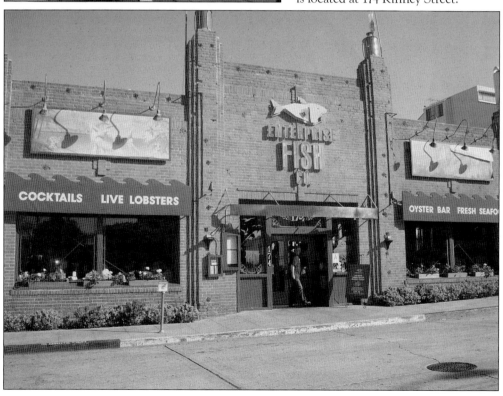

LOBSTER RESTAURANT. In 2009, the restaurant celebrated the 10th anniversary of its reopening by throwing a huge clambake for its loyal customers, city officials, and the media. It was built at 1602 Ocean Avenue on the site of the first Lobster House Restaurant, originally constructed in 1923 as a real estate office and located next to the Santa Monica Pier.

PACIFIC DINING CAR RESTAURANT. In 1921, Fred and Grace Cook brought with them the idea for a restaurant from New York, where they dined in an authentic dining car remodeled as a restaurant. They decided to build a replica of a dining car and ran it at different locations in Southern California. Throughout the 1920s and 1930s, a T-bone steak was $1 and coffee 10¢. In October 1990, the Pacific Dining Car opened in Santa Monica at 2702 Wilshire Boulevard.

BOB BURNS RESTAURANT. In 1949, Elizabeth Teeter married Robert Burns and began a partnership in love and devotion as well as for the Bob Burns Restaurants, in which they both worked diligently. Beginning with the first coffee shop in North Hollywood, the business grew to three fine-dining places, which included Santa Monica by 1971, the year of Bob's untimely death. Elizabeth operated the Bob Burns Restaurant until it closed and the property leased to Hillstone Restaurant in August 2002.

MADAME SYLVIA WU. For four decades, Madame Wu had one of the most popular restaurants in Santa Monica, Madame Wu's Garden, which opened in 1959 on Wilshire Boulevard at Twenty-second Street. Some of her numerous celebrity customers included Cary Grant, Elizabeth Taylor, Jack Benny, and Johnny Carson. Madame Wu is also the author of many popular cookbooks. She came to the United States from China to attend Columbia University Teachers College in 1944. Whole Foods is now located at the site.

Three
LUXURY HOTELS, CHURCHES, EARTHQUAKE, REAGAN

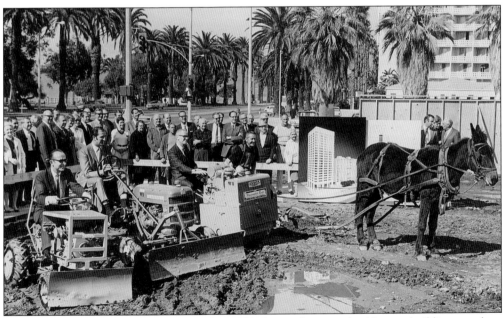

WILSHIRE PALISADES BUILDING. Located at 1229 Ocean Avenue, the 13-story building stands at the former location of the home of Arcadia Bandini de Baker, widow of Col. Robert S. Baker, who, with Sen. John P. Jones, founded the town of Santa Monica. In 1936, the house was demolished to make way for an apartment building that was later razed to allow the present structure to be erected. Welk is picture with a horse and plow at the ground-breaking. (Courtesy Lawrence Welk.)

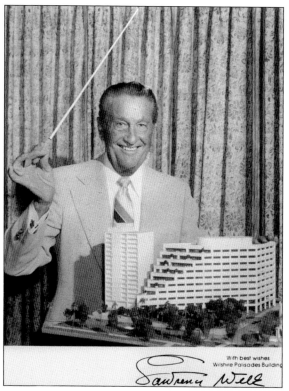

LAWRENCE WELK PLAZA. Located at Wilshire Boulevard and Ocean Avenue, the Welk Plaza, a combination commercial/residential complex, was built by renowned bandleader Lawrence Welk in 1969. The office structure commonly known as the General Telephone Building is the tallest building in the city, rising 22 stories. (Courtesy Lawrence Welk.)

CHAMPAGNE TOWERS. Located at 1221 Ocean Avenue, just south of the General Telephone Building, is the 16-story, 120-unit Champagne Towers apartment building, designed by Daniel, Mann, Johnson, and Mendenhall in 1969. The name was taken from Lawrence Welk's "Champagne Music." A flower-like metal sculpture directly in front of the Champagne Towers was created in 1969 by Peter Stein of Malibu. (Courtesy Lawrence Welk.)

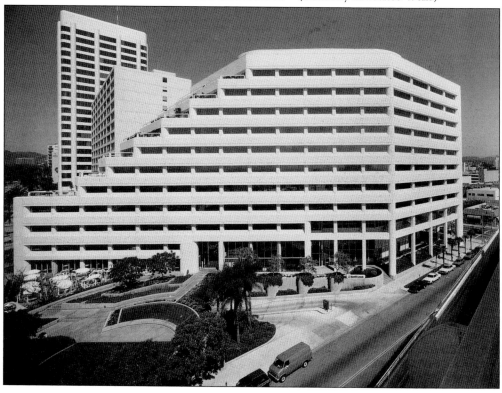

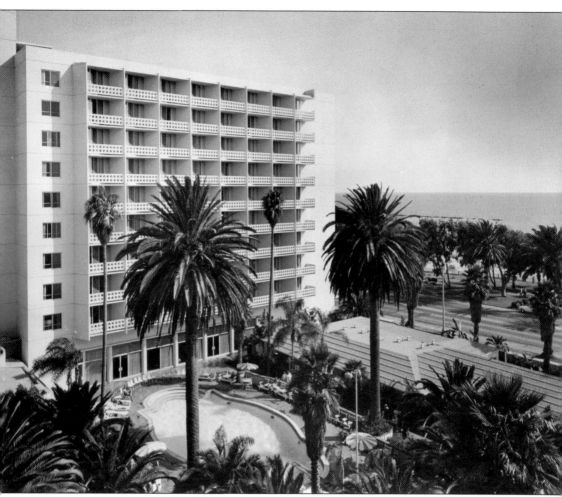

FAIRMONT MIRAMAR HOTEL AND BUNGALOWS. The Fairmont Miramar is one of the most elegant hotels in Santa Monica and offers luxury accommodations that have attracted many public figures and celebrities for over 100 years. Located at 101 Wilshire Boulevard, the hotel has 302 guest rooms, including 32 garden bungalows on the site where Santa Monica's cofounder Sen. John P. Jones had his mansion, Miramar, Spanish for "view of the ocean." When Senator Jones died in 1912, the property was sold to King Gillette, inventor of the safety razor. It was leased to a military academy at the end of World War I and sold to hotelier Gilbert Stevenson in 1921 and named Miramar Hotel. By 1938, the original structure was replaced by a modern building and bungalows. In 1959, Joseph Massaglia oversaw the construction of the Miramar's 10-story tower. Fujita acquired the property in 1973, and in 1978, ITT Sheraton became the management company. Maritz-Wolfe & Co. purchased the property in September 1959, and on November 1999, Fairmont Hotels & Resorts acquired the management contract. In 2010, S.D. Capital became the hotel's owner. (Courtesy Fairmont Miramar Hotel.)

VICEROY HOTEL. Originally built in 1969 as the Pacific Shore Hotel, the property underwent a complete renovation and interior redesign in 2001 and 2002 to be reborn as Viceroy, Santa Monica. A 14-foot-tall light-fixture sculpture marks the site of the eight-story hotel, which has 162 guest rooms, most with ocean views. The Viceroy is located at 1819 Ocean Avenue.

SANTA MONICA SHORES. Located at 2700 Neilson Way, the twin 17-story apartment buildings were built in 1964 by the Del Webb Corporation as the initial phase of a proposed redevelopment project. The architects were Beckett and Associates.

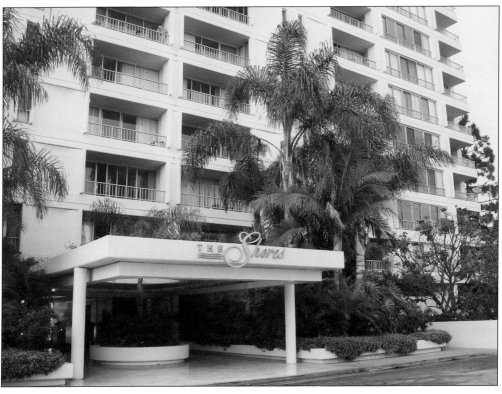

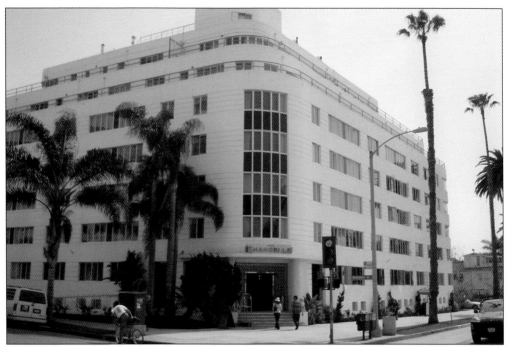

HOTEL SHANGRI-LA. Built in 1939, the hotel is an example of Streamline Moderne architecture. For decades, its 71 luxurious rooms have provided a popular hideaway for guests ranging from presidents and luminaries to movie stars, artists, and world travelers. In August 2008, the hotel reopened after a $25-million refurbishment, its first renovation in over 20 years. It is located at 1301 Ocean Avenue.

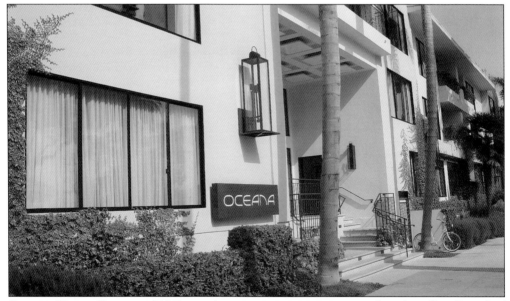

OCEANA HOTEL. Years ago, 849 Ocean Avenue was an apartment complex where Stan Laurel, of Laurel and Hardy, once lived. When it needed renovation, a group took control and converted the structure into the Oceana Santa Monica, a luxury boutique property. After a $16-million renovation, the hotel reopened in 2007.

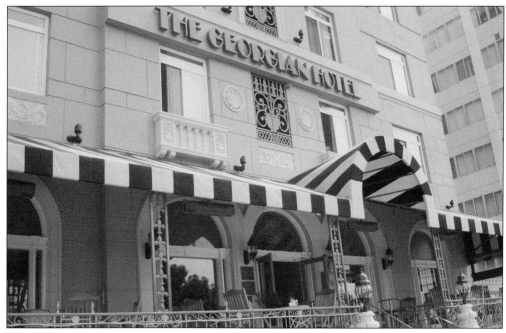

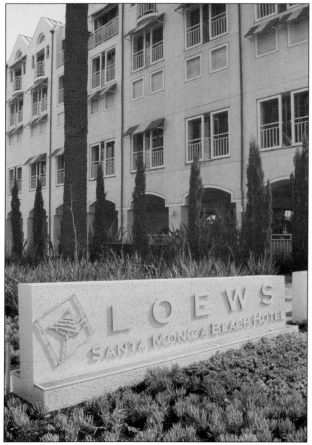

THE GEORGIAN HOTEL. Located at 1415 Ocean Avenue, the hotel was built in 1933. During Prohibition, the Georgian was home to one of Los Angeles's first speakeasies and soon became the rendezvous point for Hollywood studio executives and celebrities, including Clark Gable and Carole Lombard. In 1997, a $5-million renovation was completed that recreated and enhanced the hotel's original Art Deco architecture and appointments.

LOEWS SANTA MONICA BEACH HOTEL. Located at 1700 Ocean Avenue, the hotel opened in 1989. It completed a $15-million renovation in 2001 and has 340 rooms, including 13 suites, furnished with an elegant, casual, Southern California style. The hotel has an eight-story glass atrium with 45-foot palms and panoramic ocean views and is reminiscent of the Victorian era, when Santa Monica flourished as a resort community.

SHERATON DELFINA HOTEL. At 530 Pico Boulevard, the two-building property, originally constructed in 1981, underwent an $11-million renovation and reopened on March 15, 2005. The Delfina has 310 spacious guest rooms and 11 elegant suites, many with pool and ocean views. The hotel has the only penthouse ballroom in the city, offering 4,500 square feet overlooking the Pacific Ocean and coastline.

CASA DEL MAR HOTEL. Originally the Casa Del Mar Beach Club, the five-story club, built in 1924, was the largest of several beach clubs along the oceanfront. In the 1960s, it became the headquarters of the Synanon Fellowship and later the Pritikin Longevity Center. In 1999, the Casa Del Mar was restored after a reported $60-million renovation by the owners of Shutters Hotel, the Edward Thomas Hospitality Corporation.

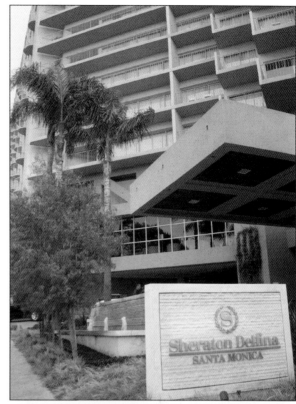

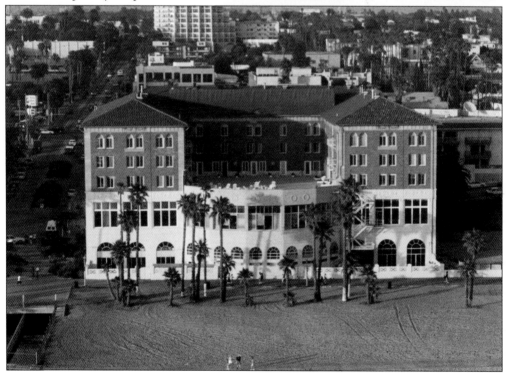

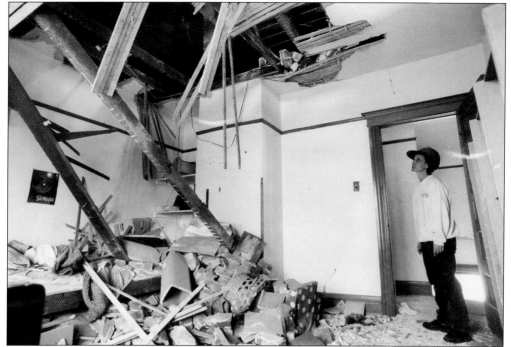

NORTHRIDGE EARTHQUAKE. The January 17, 1994, 6.8 earthquake heavily damaged Santa Monica. Approximately $200 million in losses occurred: 134 buildings were unsafe for occupancy and 396 others were damaged enough to limit access. This photograph shows the destruction at Sea Castle Apartments. The most severe impact to health care facilities occurred in the Santa Monica area. With total costs estimated to be at least $10 billion, it was the most expensive earthquake in United States history to date.

PILGRIM LUTHERAN CHURCH. The church is located at 1730 Wilshire Boulevard and is the only church on that street. It is a redbrick structure constructed in 1953 to replace the former church at Fourteenth Street and Arizona Avenue.

Trinity Baptist Church. The church was established on January 4, 1925. In 1950, a new sanctuary, built with the help of church volunteers, was dedicated. Through the years, Trinity has expanded its use of the property and sponsors a highly regarded preschool, Trinity Baptist Children's Center, at 1019 California Avenue. The church is located at 1015 California Avenue.

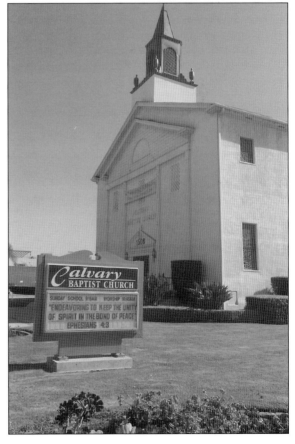

Calvary Baptist Church. Calvary Baptist Church was founded in 1920 under the leadership of Dr. Welford P. Carter, superintendent of Negro Work of the Southern California Baptist Convention. The Seventh-day Adventist Church on Sixth Street was secured as an interim place of worship. The Welford Carter Education Center was built in 1954–1955 on the present church campus. Pastor Carter passed away January 21, 1965. The church celebrated its 90th anniversary in 2010. It is located at 1502 Twentieth Street. (Courtesy Agnes Garcia.)

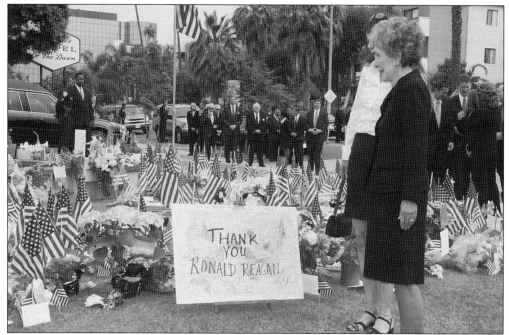

PRES. RONALD REAGAN MOURNED. In Santa Monica, flags, flowers, and personal tributes festooned the exterior of the Gates Kingsley & Gates Mortuary at Arizona Avenue and Twentieth Street, where the former president's body was taken after his death on June 5, 2004. People of all ages flocked to the funeral home to pay their respects and pray with their fellow Americans. President Reagan built his legacy on hope and was known for his youthful spirit and optimism. (Courtesy Kevin Herrera/*Daily Press*.)

MOUNT OLIVE LUTHERAN CHURCH. This church, located at 1343 Ocean Park Boulevard, was established on the site in 1949, having been previously located on Sixteenth Street, north of Ocean Park Boulevard. Designed by architect Culver Heaton, the present structure was built in 1961.

Four

CELEBRITIES AND CELEBRATIONS

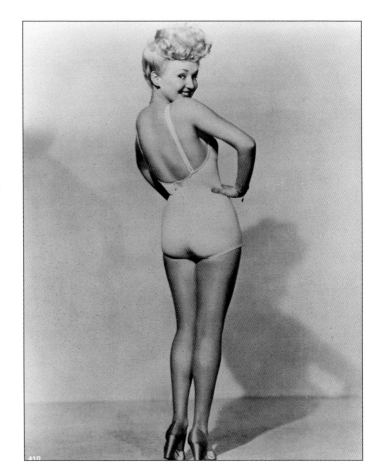

BETTY GRABLE. During the 1930s, Betty Grable was the featured vocalist at the Santa Monica Miramar Hotel's lounge. In 1931, she was signed by Goldwyn Studios and was later picked up by RKO Studios. By 1937, Grable was an aspiring starlet who switched to Paramount Studios and, in 1940, moved to 20th Century Fox. She starred in a number of top films. During World War II, GIs made Grable the number one pinup girl and this made her famous. She passed away in 1973. (Courtesy Marc Wanamaker/ Bison Archives.)

BARBARA BILLINGSLEY. Actress Barbara Billingsley lived in Santa Monica Canyon for many years. She began acting professionally on stage and even had a short stint on Broadway. Her movie career consisted of parts in good movies with fine actors such as Angela Lansbury and Clark Gable. Barbara is probably best known for her role as June Cleaver on the television show *Leave it to Beaver*. She was the honorary chairwoman of the Santa Monica Salvation Army's Centennial Celebration. Barbara passed away in 2010. (Courtesy Barbara Billingsley.)

ST. ANNE'S CATHOLIC CHURCH, SHRINE, AND SCHOOL. Located at 2017 Colorado Avenue, St. Anne's Catholic Church was established in 1908 by Fr. Patrick Howe, pastor of St. Monica's Catholic Church. The school was added in 1923. A statue in front of the school is dedicated to Father Howe. St. Anne's current pastor is Fr. Arturo Corral.

JOE REGALBUTO. Joe Regalbuto became an Emmy-winning actor during his 10 years playing Frank Fontana on the hit show *Murphy Brown*. Joe and his wife, Rosemary, moved to Santa Monica from New York in 1980 to begin work on a television series. Joe has dedicated the last several years to directing television shows such as *Friends*, *George Lopez*, and *Veronica's Closet*. His skills as a director stem from his stage-acting background. (Courtesy Joe Regalbuto.)

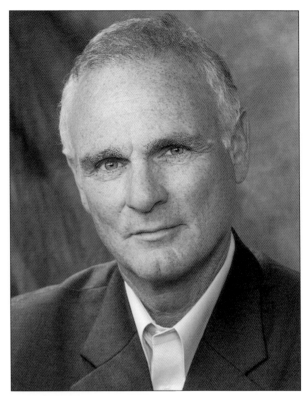

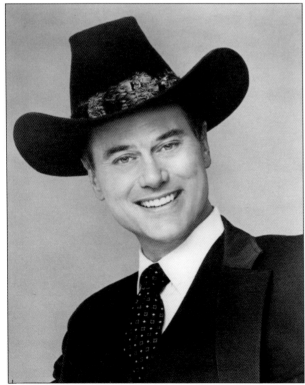

LARRY HAGMAN. Larry Hagman is best known for his role on *Dallas*. On November 21, 1980, over 350 million fans in 57 countries were glued to their television sets to find out who shot J.R. He served as executive producer for the second *Dallas* reunion movie, *War of the Ewings*. He also starred in *I Dream Of Jeannie*. Larry was born in Fort Worth, Texas, the son of actress Mary Martin and attorney Ben Hagman. In his personal life, Larry is a supporter and contributor to protecting the environment and green energy. He has the largest solar paneled home in California. (Courtesy Marc Wanamaker/Bison Archives.)

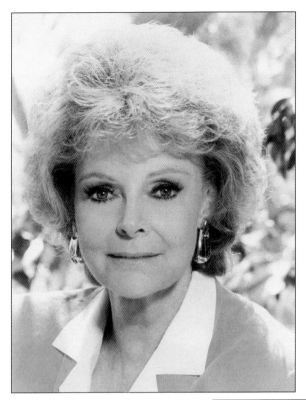

JUNE LOCKHART. A longtime community activist and resident of Santa Monica, actress June Lockhart was *the* television mom of the 1950s and 1960s. She joined the long-running *Lassie* in its fifth season, replacing Cloris Leachman as Timmy's mother. Lockhart later played Maureen Robinson on the 1960s series *Lost in Space*. She made her stage debut at age eight. (Courtesy June Lockhart.)

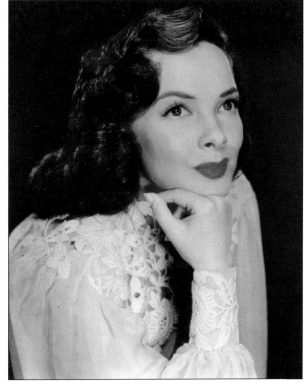

KATHRYN GRAYSON. The actress and singer lived at 2009 La Mesa Drive for many years. She starred in MGM musicals of the 1940s and 1950s, including *Kiss Me Kate*, *Show Boat*, *The Desert Song*, *Anchors Away*, and *As Thousands Cheer*. Grayson also appeared in a number of operas, such as *Madama Butterfly* and *La Traviata*. She passed away in 2010 at the age of 88. (Courtesy Marc Wanamaker/Bison Archives.)

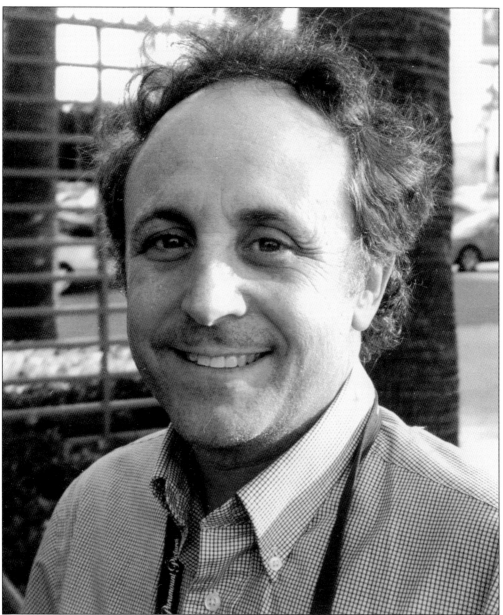

MARC WANAMAKER, FILM HISTORIAN AND AUTHOR. When Wanamaker was a young child, the beaches were his favorite destinations. He became a junior lifeguard in Santa Monica and worked several jobs at the Ocean Park Pier. In 1970, Wanamaker began researching the history of motion picture studios in the United States and the American film industry in general. Santa Monica played an important part in the development of the film business, beginning in 1911 with the establishment of the Vitograph Studio and continuing with the Bison Film Company and, later, Thomas Ince Studios in Santa Ynez Canyon. Location filmmaking also became of great interest to Wanamaker, and for many years he has been compiling lists of films and television shows shot in the Santa Monica area. In 1971, he founded the Bison Archive, a research library on the history of the motion picture industry and Southern California and its numerous cities. He serves the Santa Monica History Museum as its film historian. (Courtesy Marc Wanamaker/Bison Archives.)

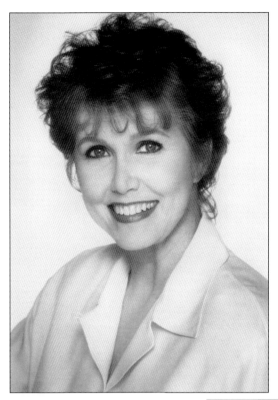

STEPHANIE EDWARDS. For a number of years, Stephanie Edwards resided in Santa Monica. She was the honorary chairwoman of the Santa Monica Salvation Army Women's Auxiliary Christmas in September benefit for needy families for many years. Since 1968, she has had a varied career as an interviewer and commentator and has made 15 guest appearances on the *Tonight Show*. Since 1978, Edwards has been the popular, longtime cohost with Bob Eubanks of KTLA's broadcast of the Tournament of Roses Parade. (Courtesy Stephanie Edwards.)

JUBILANT SYKES. A classically trained baritone vocalist, Santa Monican Jubilant Sykes is a respected opera, jazz, and spiritual vocalist of the late 1990s. Sykes has sung at the Metropolitan Opera and performed with the Boston Pops, London Symphony Orchestra, Los Angeles Philharmonic, and among many other organizations. (Courtesy Rena Mckinzie.)

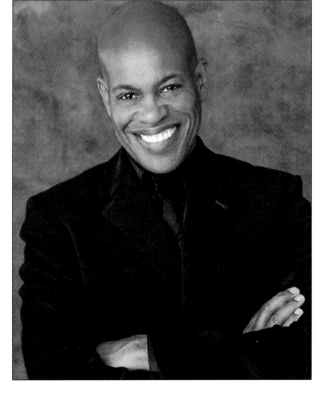

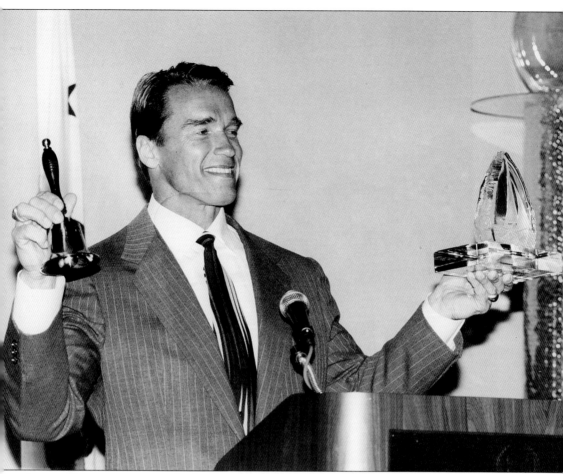

ARNOLD SCHWARZENEGGER. At the age of 14, Schwarzenegger chose bodybuilding over football (soccer) as a career. In 1968, at the age of 21, he moved to the United States from Austria and began training at Gold's Gym in Santa Monica. His goal was to become the greatest bodybuilder in the world: Mr. Olympia. At 23, Schwarzenegger won that title. He spent some time at Santa Monica's Muscle Beach. After winning the 1975 Mr. Olympia contest, he announced his retirement from professional bodybuilding and decided to go into acting. Schwarzenegger became a Hollywood superstar, and among his box-office blockbusters are the three *Terminator* films. In 1992, he and his wife, Maria Shriver, opened a restaurant in Santa Monica called Schatzi on Main Street. They sold the eatery in 1998, but they still do business in Santa Monica. In 2003, Schwarzenegger began two terms as governor of California. He is shown here receiving the Citizen of the Year award from the City of Santa Monica, Santa Monica Chamber of Commerce, and the Santa Monica Board of Education in the 1980s. (Courtesy Santa Monica Chamber of Commerce.)

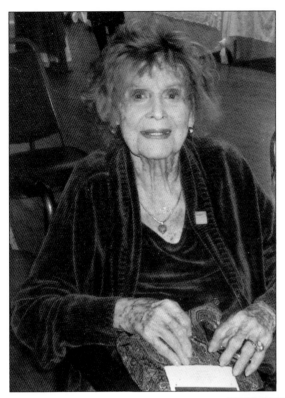

GLORIA STUART, ACTRESS. Stuart was born on July 4, 1910, in Santa Monica. She attended the town's first school and graduated from Santa Monica High School in 1927. In a surprise visit to the Santa Monica History Museum's July 11, 2010, community celebration for the City of Santa Monica's 135th birthday, she was also honored for her 100th birthday. Stuart is best known for her role as the 100-year-old Rose DeWitt Bukater in the 1997 movie *Titanic*. Stuart passed away on September 26, 2010.

MAE LABORDE. Actress Mae Laborde celebrated her 100th birthday in 2009 at a community party hosted by the Santa Monica History Museum. Active all of her life, she worked at several jobs, including at First Federal Bank and Hensheys Department Store and for Lawrence Welk. At the age of 93, she began her acting career and has appeared numerous times on television commercials for Lexus, Sears, and JPMorgan Chase, to name a few.

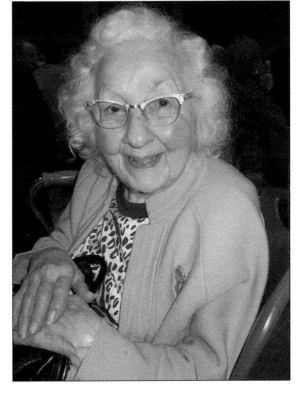

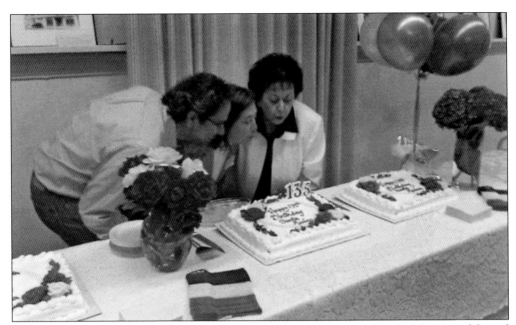

SANTA MONICA'S 135TH BIRTHDAY. On July 11, 2010, the Santa Monica History Museum celebrated the city's 135th anniversary at the Santa Monica Bay Womans Club with service clubs as sponsors. Highlights of the event included a surprise visit by actress Gloria Stuart, a Journey Into the Past history exhibit, entertainment by the Oceanaires, and a rare film from Santa Monica's centennial. Pictured from left to right are city council members Richard Bloom and Gleam Davis with Louise Gabriel, president of the museum.

SANTA MONICA PIER CENTENNIAL. On September 9, 2009, the Santa Monica Pier celebrated its centennial with pomp and pageantry. At night, the pier held its first fireworks in 18 years. The event was planned by Ben Franz-Knight, executive director of the Pier Restoration Corporation and board members. Pier historian James Harris authored the book *Santa Monica Pier: A Century on the Last Great Pleasure Pier*. (Courtesy Jim Harris/Santa Monica Pier Restoration Corporation.)

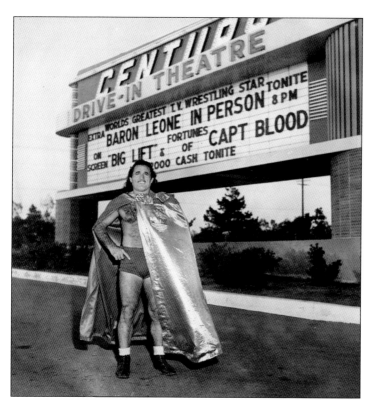

BARON MICHEL LEONE. Baron Leone pioneered professional wrestling in the United States and then helped usher in millions of additional fans across the country when television began airing the sport and many of his wrestling matches in the 1950s. Many Hollywood starlets and actors attended the events, and the Baron's popularity skyrocketed. He became recognized as the world's heavyweight titleholder. Baron Leone lived in Ocean Park for many years with his wife, Billie. (Courtesy Billie Leone.)

STAN LAUREL CENTENNIAL BIRTHDAY. The Santa Monica History Museum held a citywide celebration for the centennial of longtime resident Stan Laurel's (of Laurel and Hardy) birthday. Several events were held, including a look-alike contest and gala dinner. Through the museum, a pictorial postmark with the image of Stan Laurel was made available to the public on September 13, 1990, to commemorate Laurel's June 1890 birth in Lancashire, England.

SANTA MONICA'S BIRTHDAY CELEBRATIONS. Since 1985, the Santa Monica History Museum has held community-wide celebrations for the city's milestone birthdays. For the 110th birthday, festivities included a parade of antique and classic cars down Wilshire Boulevard, a cake cutting at city hall, and 110 people at the beach, each carrying a balloon and releasing them at the same time, which was covered by the media and television stations. The finale was a dinner held at the Miramar Hotel where John Farquhar, grandson of Santa Monica cofounder Sen. John P. Jones, and Linda Sepulveda Eastman, a descendent of Don Francisco Sepulveda, original owner of the Santa Monica land grant, pictured here, blew out the candles on the birthday cake. For the city's 125th birthday, a celebration was held at Clover Park with the police and fire departments and service clubs participating. Following the entertainment, cake was served to several hundred people.

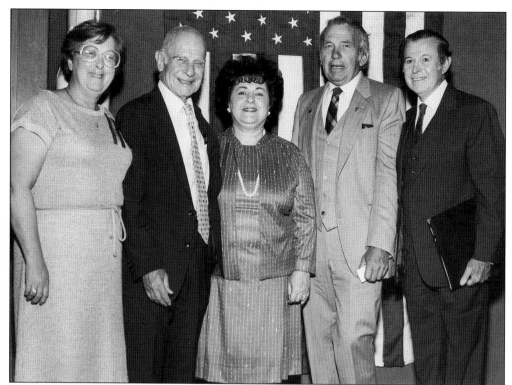

BICENTENNIAL OF FLIGHT. A Bicentennial of Flight celebration in 1983 was hosted by the Santa Monica History Museum at the Miramar Sheraton Hotel. It commemorated the 1783 hot-air balloon flight by Etienne Montgolfier in France. Among the participants pictured are, from left to right, Lillian Abelson, event cochair; Gen. James Doolittle (Ret.); Louise Gabriel, event cochair; Donald Douglas Jr.; and vocalist Dennis Day. The festivities included the United States Military Band and an exhibit from the Donald Douglas Aerospace Museum. Over 1,000 people attended the event.

SANTA MONICA AIRPORT'S 65TH ANNIVERSARY. In October 1984, the Santa Monica History Museum sponsored a Community Fun Festival with the Donald Douglas Museum in celebration of the Santa Monica Airport's 65th anniversary. Local and state officials participated in the program. A host of professional entertainers and celebrities highlighted the event. Over 40 service organizations participated, and over 40,000 people were in attendance.

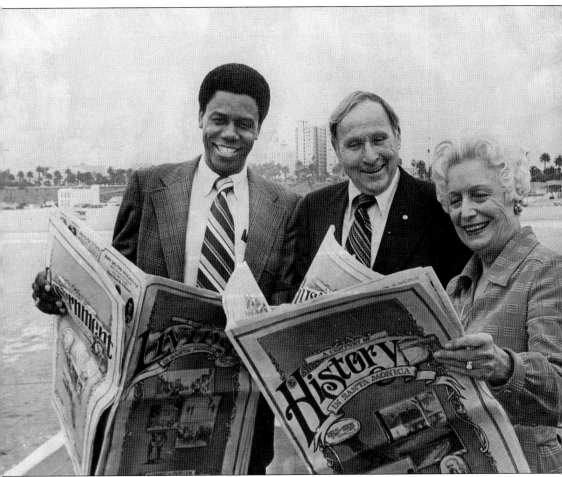

SANTA MONICA CENTENNIAL CELEBRATION. Pictured is a 1975 *Evening Outlook* Santa Monica Centennial edition viewed by, from left to right, Santa Monica mayor Nat Trives, centennial committee chair Aubrey E. Austin Jr., and former mayor Clo Hoover, honorary chair. As the spirit of the centennial celebration developed, organizations, businesses, and many individuals devised unique ways of participating. Among the many events and activities held were a play at Morgan Wixon Theatre, one of the largest square dances ever held locally, and a Santa Monica history scrapbook exhibit held at the Civic Auditorium. Santa Monican May Sutton Bundy, the first American woman to win the tennis championship at Wimbledon, rode atop the City of Santa Monica and Santa Monica Chamber of Commerce giant birthday-cake float in the Pasadena Tournament of Roses Parade. To culminate the centennial celebration, a gala dinner was held at the Civic Auditorium with entertainment by Lawrence Welk and his musical family. It was under the centennial committee that the Santa Monica Historical Society, now the Santa Monica History Museum, was founded, with former mayor Hoover as its first president.

Dorothy Stock "Dottie" Dellinger. After volunteering with the Westside Republican Council, Dellinger, a Santa Monica resident, was asked to help with a backlog of mail in 1975 that had been sent to Ronald Reagan, then the former governor of California. She arrived in Washington after Reagan was elected president in 1980 and served as deputy director of the White House Visitor's Office and later as staff assistant to the president. After Reagan left office in 1989, Dellinger was his executive assistant in Los Angeles until 1994. (Courtesy Kip Dellinger.)

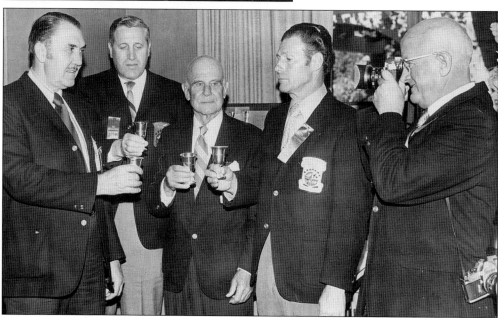

Gen. James Doolittle. A former resident of Santa Monica, Gen. James Doolittle received the Medal of Honor for leading the April 1942 bombing raid on the Japanese mainland. Doolittle is pictured (center) at the annual reunion of men who flew on the raid over Tokyo. With him are, from left to right, "Raiders" Chase J. Nielsen, Henry A. Potter, Travis Hoover, and Dr. Thomas R. White. Doolittle was an outstanding Air Force flyer and set the world speed record for cargo planes in 1935.

Five

LUMINARIES

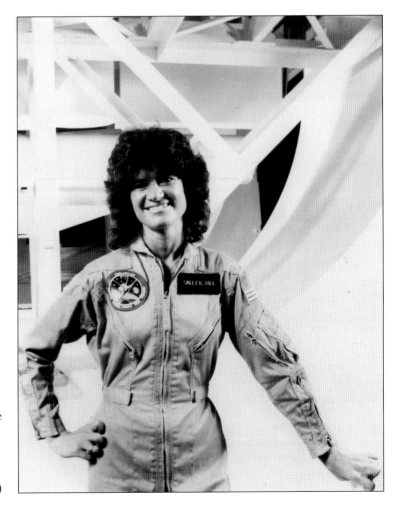

SALLY RIDE, FIRST FEMALE ASTRONAUT. Sally Ride, born in Santa Monica, was a mission specialist for the Earth-orbiting space shuttle *Challenger* flight on June 18, 1983. Her father, Dale Ride, taught at Lincoln Junior High and Santa Monica College. Sally attended Swarthmore College and transferred to Stanford University, where she earned a bachelor of arts in English, bachelor of science in astronomy, master of science in physics, and doctorate in astrophysics. In 1978, Ride was selected to the astronaut program. (Courtesy Sally Ride.)

J.B. Nethercutt. Born in Indiana, J.B. Nethercutt moved to Santa Monica in 1923 to live with his aunt, the founder of Merle Norman Cosmetics. In 1933, Nethercutt married Dorothy Sykes. They loved old cars, and in 1956, he purchased a 1936 Duesenberg convertible roadster and a 1930 DuPont Town Car. A number of classic cars are displayed in the J.B. Nethercutt Museum, which opened in 1971 in Sylmar, California. (Courtesy J.B. Nethercutt.)

Merle Norman. The history of Merle Norman Cosmetics began in her home in Ocean Park in 1931. Norman's kitchen served as her first laboratory, where she mixed ingredients in a large pot on her stove. She was joined in the business by her nephew J.B. Nethercutt. With his expertise in chemistry and her unlimited enthusiasm for sales and public relations, Merle Norman Cosmetics blossomed and grew to become one of the largest cosmetic firms today. (Courtesy Tom Dixon.)

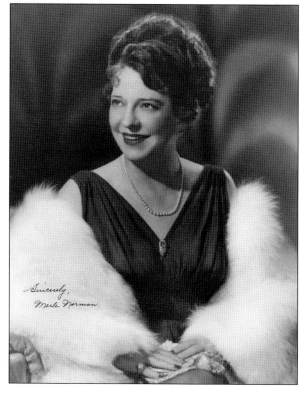

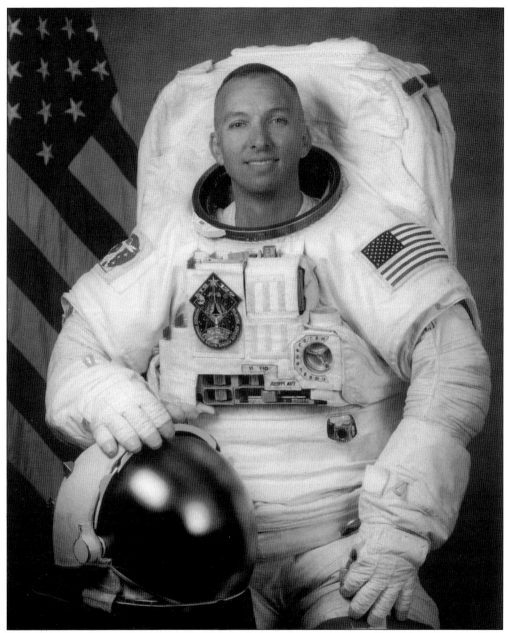

RANDY BRESNIK, ASTRONAUT. Bresnik, raised in Santa Monica, graduated from Santa Monica High School in 1985 and went on to become one of six NASA astronauts to launch in November 2009 on STS-129 *Atlantis*. The 11-day space shuttle flight to the International Space Station helped outfit the outpost with critical spare parts in advance of the shuttle fleet's retirement in 2011. Bresnik will participate in the second and third of the missions' three separate space walks. He wanted to pay tribute to his grandfather Albert Bresnik, who was the personal photographer for Amelia Earhart, so he borrowed a photograph of his and Earhart's lucky scarf from the Ninety-Nines Museum of Women Pilots in Oklahoma City to take with him on the mission. Earhart always wore her multicolored scarf on long-distance flights, but for some reason did not wear it on the ill-fated trip in 1937, when she disappeared over the Pacific near Howland Island. (Courtesy A.R. Bresnik.)

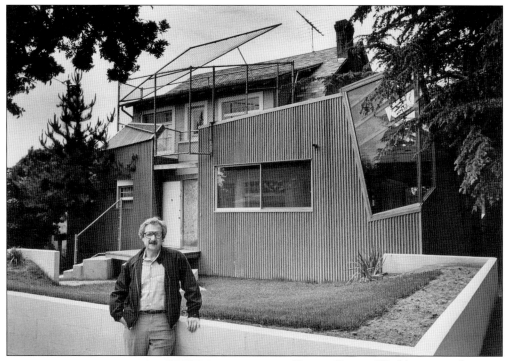

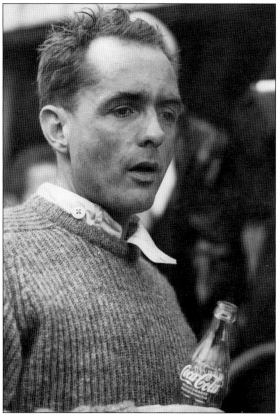

Frank Gehry. World-renowned architect Frank Gehry has a reputation for incorporating free-flowing and artistic expression in his buildings. Among his works are Santa Monica Place, the Walt Disney Concert Hall, the Sleep Train Pavilion in Northern California, and the Museum of Contemporary Art. His Outside-in-House in Santa Monica won an architectural award in 1979. Gehry's work is a highly refined, sophisticated, and adventurous aesthetic that emphasizes the art of architecture.

Phil Hill Jr. One of the greatest American auto racers, Phil Hill grew up in Santa Monica where his father was a postmaster. At the height of his career, Hill raced in Europe and Latin America and won many races over the years. After retiring as a driver in 1967, Hill worked as a racing commentator for ABC and as a contributing editor to *Road & Track* magazine. He also devoted time to classic cars and auto restoration. (Courtesy the Hill family.)

AMELIA EARHART. Aviation pioneer and author Earhart was the first woman to receive the Distinguished Flying Cross, which she received for becoming the first aviator to fly solo across the Atlantic Ocean. Earhart's passion for flying began in 1920 when she took her first plane ride with her father. She made her first attempt at competitive air racing in 1929 during the first Santa Monica-to-Cleveland Women's Air Derby. Santa Monica photographer Albert Bresnik was her personal photographer. (Courtesy Albert Bresnik.)

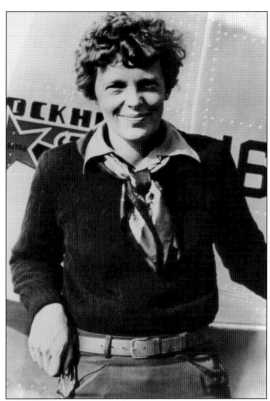

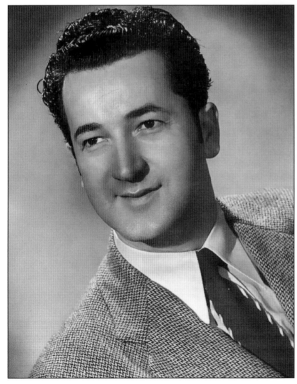

ALBERT L. BRESNIK. Bresnik was a prominent photographer of celebrities. He is most known for his portraits of the famous aviator Amelia Earhart and served as her personal photographer from 1932 to 1937, when she disappeared over the Pacific Ocean near Howland Island. Bresnik was slated to accompany Earhart and her navigator Fred Noonan on their ill-fated trip around the world, but his camera equipment was too heavy. He is the grandfather of astronaut Randy Bresnik. (Courtesy Albert Bresnik.)

PAULA BOELSEMS. Santa Monica resident Paula Boelsems is a well-known and talented adagio dancer, acrobat, circus aerialist, and actress in theater, nightclubs, circus, television, and movies. She is also a charter member of the Hollywood Stuntwomen's Association of Motion Pictures and Television, having doubled for Carol Channing in *Thoroughly Modern Millie* and Julie Andrews in *Star*. Some of her other performances were in *Camelot*, *The Towering Inferno*, *The Poseidon Adventure*, and *Batman Returns*. At the age of eight, Boelsems discovered Muscle Beach, where young people were flying off rings and bars and doing tricks on a wrestling mat. She progressed from a little girl begging people to teach her a few tricks to one of the most graceful and top athletes at Muscle Beach. Paula became a teacher for the Los Angeles Unified School District and taught for four years. In 1960, she was chosen along with other teachers to write the curriculum for the reintroduction of gymnastics in the Los Angeles School girls' physical education program. She has received numerous honors and awards for her work. (Courtesy Paula Boelsems.)

MARY REHWALD. In the traditionally male-dominated automotive business, Mary Rehwald (forefront) made her mark. She inherited the W.I. Simonson Mercedes Benz dealership when her father passed away in 1978. It flourished under her leadership and that of her three children, from left to right, William, Francie, and Judy. It was a challenge for a woman to own a dealership, and Mary had several opportunities to sell the building, but her decision to keep it was partly a sentimental one. Her dad started with nothing, and in 10 short years, he owned it. In 1986, a fire caused by a careless smoker destroyed the building. Since the plans no longer existed, architect Jim Mount used photographs to recreate the building's design. During the construction of the new building, a trailer on the used car lot across the street became the temporary showroom. The dealership never lost a customer or a sale. Mary was honored with an Education Preservation Award from the Santa Monica History Museum. (Courtesy Rehwald family.)

DR. JOHN E. GILMORE. Renowned for being one of the first to implant intraocular lenses, Dr. Gilmore taught ophthalmologists his technique at Santa Monica Hospital. He studied mechanical engineering at the University of Nebraska and later applied for an orthopedic surgery residency, which led him to volunteer for the Army Air Corps, where he became a flight surgeon. During that time, he realized that plastic fragments from shattered windshields did not cause inflammatory reaction to the eye. He developed a new method of cataract surgery: intraocular lens implants.

DAVID G. PRICE. Price is chairman of American Airports Corporation, an aviation real estate fixed-base operation and airport management company that purchases, leases, and develops aviation properties. He also founded American Golf Corporation and National Golf Properties. Price developed and is chairman of the Museum of Flying at Santa Monica Airport. He owned a Douglas DC-3 airplane, which he donated to the City of Santa Monica along with a generous sum for its restoration. It was installed as a monument at Santa Monica Airport. (Courtesy David Price.)

Dr. Wally Ghurabi. Dr. Ghurabi is medical director of the Nethercutt Emergency Center at Santa Monica UCLA Medical Center and Orthopaedic Hospital, a position he has held since 1981. He also serves as medical director of the Santa Monica Fire and Police Departments and trains paramedics and first responders on various aspects of emergency medicine, including pre-hospital care. He has been at the heart of Santa Monica UCLA's response to several major disasters, including the Northridge Earthquake in 1994 and the Farmer's Market tragedy in 2003. Ghurabi directed activities at the Nethercutt Emergency Center, where victims from both incidents were taken for treatment. During his illustrious career in emergency medicine, Dr. Ghurabi has cared for tens of thousands of people needing emergency services and helped save countless lives. He also has trained hundreds of resident physicians and paramedics. He is a recipient of the American Red Cross of Santa Monica's Spirit Award for his work in promoting emergency preparedness, educating fire and police personnel, and taking care of the Santa Monica community. (Courtesy Ted Braun/Santa Monica UCLA Medical Center.)

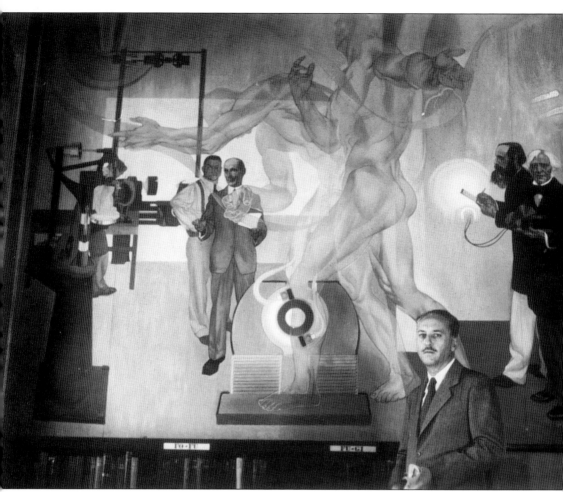

STANTON MACDONALD-WRIGHT. A Santa Monica resident and graduate of Santa Monica High School, Macdonald-Wright was California's first internationally acclaimed modern artist. By 1934, America was in the grips of the Great Depression and, like other unemployed workers, artists sought relief through Pres. Franklin D. Roosevelt's New Deal programs that were designed to put people back to work. It was Macdonald-Wright's own idea to paint a mural for the Santa Monica Public Library at 503 Santa Monica Boulevard. His proposal to the City of Santa Monica was enthusiastically received, the money quickly funded for materials, and the mural began. The mural series was on view for three decades before it was dismantled and transferred to the federal government. The mural was returned on loan from the Smithsonian American Art Museum and installed in the new Main Library in 2006. Macdonald-Wright passed away in 1973. (Courtesy Cynni Murphy/Santa Monica Public Library.)

Six
SANTA MONICA GROUPS AND ORGANIZATIONS

HEAL THE BAY. Founded in 1985, Heal the Bay is a nonprofit environmental organization dedicated to making Southern California coastal waters and watersheds—including Santa Monica Bay—safe, healthy, and clean. As part of its mission, it supports public health and education outreach programs as well as sponsoring beach cleanup programs. It also operates the Santa Monica Pier Aquarium. Heal the Bay is located at 1444 Ninth Street. (Courtesy Heal the Bay.)

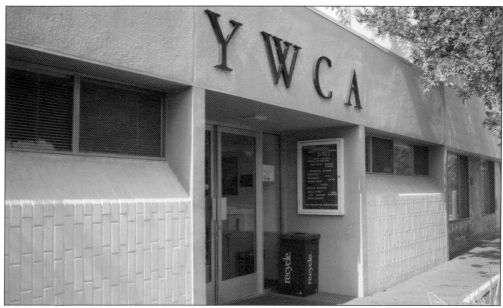

Santa Monica YWCA. The YWCA has operated from its location at 2019 Fourteenth Street since 1971, providing a broad range of programs and services. The main building, constructed in 1931, was originally known as the Amaranth House, a girls' home operated by the Amaranth Golden Rule Homes Association. The gymnasium, built in 1971, was designed by architect James Mount.

Santa Monica Family YMCA. The YMCA, located at 1332 Sixth Street, was incorporated in 1901. Through the Great Depression, it offered many youth and adult activities. In 1946, the Sixth Street property was purchased for the expanding needs, and after a successful capital campaign, a new facility opened in 1950. In 1983, the YMCA opened Ralph Kiewit Fitness, the first part of a three-year plan to enlarge the facility, which was completed in 2002. (Courtesy YMCA.)

SANTA MONICA HISTORY MUSEUM. The organization was originally named the Santa Monica Historical Society when it was founded under the Santa Monica Centennial Committee in 1975 to be the official collector and preserver of the history, art, and culture of the Santa Monica Bay area. After a few years, the collections had grown considerably. In 1988, Louise and Bob Gabriel founded the museum after three years of preparation so that artifacts and photographs could be shared with the public. The museum's vast historical treasures include thousands of artifacts, over 600,000 photographs from the *Outlook* newspaper and other sources, 7,000 original deed books from the Los Angeles County Recorder, and 40 years' worth of historical memorabilia from Sen. John P. Jones, cofounder of Santa Monica. The museum sponsored the first archeological dig in Ocean Park, a bust of Arcadia Bandini in Palisades Park, and did the research for the Santa Monica Bay Woman's Club landmark designation. On October 24, 2010, the museum opened in its new state-of-the-art facility at 1350 Seventh Street.

SANTA MONICA COLLEGE. A two-year community college accredited by the Western Association of Schools and Colleges, Santa Monica College opened in 1929 with just 153 students. It has grown to a thriving campus with 35,000 students and offerings in more than 80 fields of study. The college, which over the years has been known as Santa Monica Junior College and Santa Monica City College, opened on the second floor of the old brick Santa Monica High School building. Over the years, the college has had several sites, but its main campus at 1900 Pico Boulevard opened in 1952. The campus has gone through a major face-lift over the past two decades, with only a handful of the original buildings still remaining. SMC added five satellite campuses, including the Performing Arts Center and Academy of Entertainment and Technology. As it grew and prospered, the college's reputation for academic excellence grew with it. It is the no. 1 transfer institution to the University of California, USC, and Loyola Marymount University, and it sends significant numbers of students to elite universities such as Columbia University. (Courtesy Bruce Smith/Santa Monica College.)

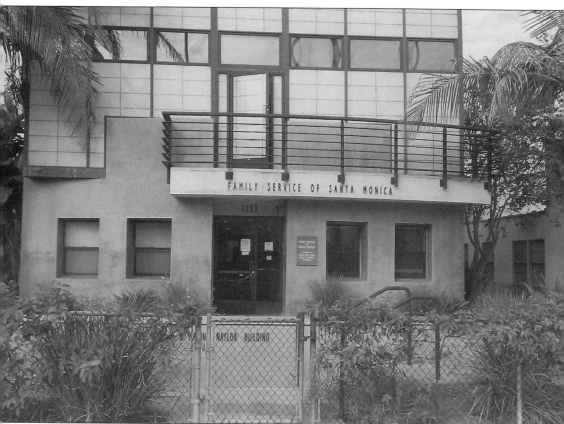

FAMILY SERVICE OF SANTA MONICA. The agency was formed in 1925 as the Council of Social Welfare. It was a forward-thinking idea for the time, an agency dedicated to providing support to individuals and families who needed help in securing adequate housing, food, and medical or dental care. With the encouragement of Mayor Herman Michel and some initial support from the city, founders Elmira T. Stephens and Emma Tegner opened their first service site at Second Street. The Kiwanis Club was instrumental in raising funds for the purchase of two lots on Euclid Street. In the late 1940s, the council changed its name to Family Service of Santa Monica. In the 1970s, director Karen Howard had a vision to build a new home for Family Services. In the 1980s, Roy Naylor and the entire board raised $700,000 to build the present facility at 1533 Euclid Street. Nancy Tallerino became the new director of the agency, which has developed and expanded its programs to promote healthier families and individuals.

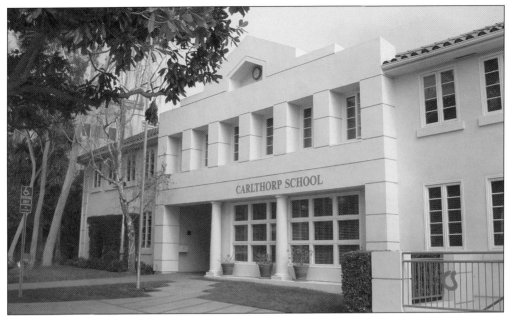

CARLTHORP SCHOOL. Carlthorp School, located at 438 San Vicente Boulevard, was founded in 1939 by Mercedes Thorp and Ann Carlson Granstrom. It is Santa Monica's oldest independent elementary school. Thorp served as principal and taught the upper grades; Granstrom, the school's director, taught lower grades. Dee Menzies, a former pupil, now heads the school. Since she joined the staff in 1983, the school has doubled in size and undergone significant academic enhancements.

JUNIOR CHAMBER OF COMMERCE—JAYCEES. The Jaycees organized in 1931. Its first major project was the Distinguished Service Award, given each year to a Jaycee for outstanding service. Over the years, the group's many projects have included Huck Finn Day and blood drives. The Jaycees are people ages 21 through 40 whose mission is to serve Santa Monica by cultivating young professionals and empowering them to lead. (Courtesy Jaycees.)

Santa Monica Bay Woman's Club. The club dates back to 1904 when it started as a history class. After meeting for 10 weeks, attendees decided to form an organization and call it Santa Monica Lecture Class. Elmira Stephens organized it and was made president. On December 11, 1905, the Woman's Club of Santa Monica was born. Arcadia Bandini de Baker, wife of Col. Robert S. Baker, cofounder of Santa Monica, donated two lots to the club. Later, a site was chosen at 1210 Fourth Street. On October 3, 1914, the club moved into its new building. The club was organized for the purpose of the advancement in all lines of culture, education, child welfare, social service, and philanthropy. During World War I, the clubhouse was opened for 18 months to accommodate the servicemen and servicewomen for dancing and for Red Cross members to knit and sew. The club made similar contributions to the war effort during World War II. Since its founding, the club has provided scholarships and supported countless charities.

SANTA MONICA CONSERVANCY. The conservancy was started in August 2002 by a group of residents who wanted to celebrate and protect Santa Monica's historic treasures. It works to promote widespread understanding and appreciation of the cultural, social, economic, and environmental benefits of historic preservation. Through educational programs, assistance, and advocacy, the conservancy reinforces the importance of preserving the historic resources of Santa Monica's unique urban landscape. (Courtesy Santa Monica Conservancy.)

CHRYSALIS. Since 1984, Chrysalis has provided critical employment to over 30,000 homeless and economically disadvantaged individuals through its service centers in downtown Los Angeles and Santa Monica. Chrysalis is dedicated to helping the less fortunate through employment opportunities. The agency offers services ranging from one-on-one mentoring to material assistance such as clothing and bus tokens. The local agency is located at 1837 Lincoln Boulevard.

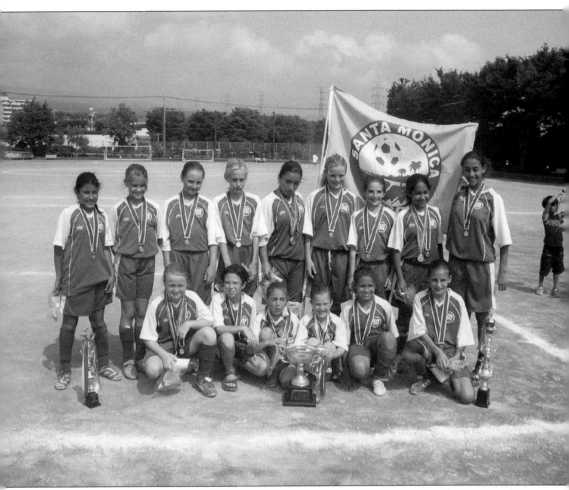

SANTA MONICA SISTER CITY. In 1961, under the leadership of councilmember Clo Hoover, the people of Santa Monica organized a Sister City Committee in response to an appeal from former Pres. Dwight Eisenhower to the American people to work for the establishment of world peace. He believed that people acting as "citizen developments" could achieve better international relations than government representatives had been able to do. The Sister City Committee of the City of Santa Monica invited Mazatlan, Mexico, to affiliate with Santa Monica in 1961. Other cities that have also affiliated with Santa Monica are Hamm, Germany; Fujinomiya, Japan; and Cassino and Sant'Elia Fiumerapido, both in Italy. The committee became a nonprofit corporation in 1967. The 2010 president is Monika White. Past presidents from 1961 to 2009 have been Al Albergate, Walt Anger, Ray Carriere, Robert Cleave, Joe Deering, Jack Delaney, Jeanette Ford, Forrest Freed, Robert Gunell, Charmaine Hagadorn, Clo Hoover, Jim Ireland, Jerry Lee, Rex Minter, Wellman Mills, John Philbin, Mel Risher, Al Swink, Nat Trives, and Dorothy Wyatt. Pictured is a local girls' soccer team, which was sponsored by Sister City and participated in the 2010 Fujinomiya Soccer Tournament. (Courtesy Monika White.)

SANTA MONICA BREAKFAST CLUB. In 1935, the Santa Monica Breakfast Club was organized as a philanthropic group to serve the needs of the community. Its first charity was the Day Nursery. During World War II, members contributed many hours to the USO, Red Cross, and Gray Lady Service. In 1949, the club decided to sponsor the Children's Dental Clinic at Santa Monica Hospital through its Diamond Luncheon. By 1997, the club had contributed $500,000 to the hospital.

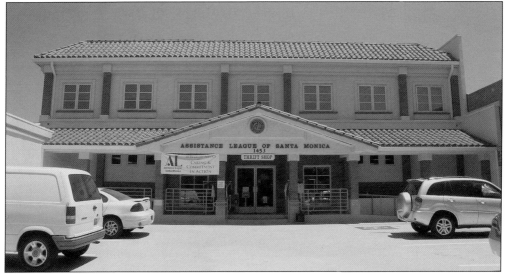

ASSISTANCE LEAGUE OF SANTA MONICA. In 1930, a guild of young women formed the Assistance League of Santa Monica to help children in need. That same year, they took control of the Santa Monica Day Nursery. Since then, the league has adopted philanthropic programs that provide services to benefit children. A thrift shop at the chapter house at 1453 Fifteenth Street raises funds for these programs. (Courtesy Assistance League of Santa Monica.)

EMPLOYEES COMMUNITY FUND OF BOEING CALIFORNIA. An employee-owned and -operated nonprofit organization, Employee Community Fund of Boeing California combines the assets of the former Douglas Aircraft Welfare Foundation and the contributions of Boeing employees made through payroll deductions to support charitable organizations in areas where contributors live and work. The fund supports a wide range of vital human services. (Courtesy Employees Community Fund of Boeing.)

SALVATION ARMY WOMEN'S AUXILIARY. Founded in 1964, the auxiliary's purpose is to assist the Salvation Army, in cooperation with the advisory board, with all Salvation Army activities in the community and undertake special fundraising projects. For over 30 years, the auxiliary has hosted a Christmas in September Fashion Luncheon to benefit needy children. It assists the Salvation Army with the shopping spree for children, Red Kettle Day, Veterans Services, and Camperships.

MONIKA WHITE. White served as president and CEO of Center For Healthy Aging, a nonprofit organization founded in 1974 and dedicated to providing a wide range of health and support services to those 55 and older. She served from 1995 until her retirement in 2007. The center merged with WISE Senior Services and became WISE and Healthy Aging. A retirement party was held for White at the Ken Edwards Center. Former mayor Richard Bloom was among the dignitaries who presented a commendation of appreciation from the City of Santa Monica. It was one of the many from a variety of institutions and government agencies that included the California State Senate and Assembly, City of Los Angeles, Department of Aging, County Board of Supervisors, Gov. Arnold Schwarzenegger, and the USC Davis School of Gerontology, where Dr. White is an adjunct associate professor. White is also an author, lecturer, and consultant. She is active in many community organizations, including the Rotary Club, Santa Monica College Associates, and Santa Monica Sister City, for which she serves as president. (Courtesy Monika White.)

Seven
COMMUNITY PILLARS

JANE NEWCOMB WHITING. Born in Santa Monica, Whiting is the daughter of Walter and Enid Newcomb, who operated the Newcomb portion of the Santa Monica Pier for 30 years beginning in 1943, including the carousel and La Monica Ballroom. Her sister and brother-in-law, Bette and Dick Westbrook, ran the well-known pier restaurants Sinbad's and Moby's Dock. During World War II, Whiting joined the navy as a member of WAVES and served in Florida as a link trainer instructor for pilots learning navigational skills. She has been a supporter of the Santa Monica History Museum for 35 years. (Courtesy Kathy Whiting.)

CAROLE CURREY. A former member of the Santa Monica–Malibu Unified School District Board of Education, Currey was elected to the Santa Monica College Board of Trustees in 1979 and has served five stints as chair. She was elected five times to the California Community College Trustees Board of Directors and served as president in 2001 and 2002. Currey has served many years on the Advisory Board of Family Service of Santa Monica and on the Santa Monica History Museum Board. (Courtesy Carole Currey.)

VIRGINIA TEGNER SPURGIN. Spurgin, who has supported many worthy causes, contributed the seed money for the John Drescher Planetarium at Santa Monica College. She is a past president of the Santa Monica College Foundation and a founding and life member of the Santa Monica History Museum, whose board she served on for 10 years. Her grandfather Charles Tegner was the builder and owner of both the first theater in the city, the Majestic, and the first department store, Hensheys. (Courtesy Caroline Tegner Spurgin.)

LOUISE B. GABRIEL. Gabriel has given over 45 years of ongoing volunteer service to the community and has been recognized by many organizations, the City of Santa Monica, and Los Angeles County for her longtime service and tireless efforts. She is president and founder of the Santa Monica History Museum, past president of Santa Monica College Patrons, Santa Monica Hospital Auxiliary, Boys Club Auxiliary, Santa Monica Bay Woman's Club, and Salvation Army Auxiliary. She is a past chair of the Salvation Army Advisory Board, on which she served for 25 years. Her other services include chairing the city's celebration for the bicentennial of the Constitution, the Salvation Army's 100th Anniversary, and a rose float in the Pasadena Tournament of Roses Parade for the City of Santa Monica and Santa Monica Chamber of Commerce. She has received many awards over the years, including from the Boys Club of America, three city mayors, YWCA, chamber of commerce, Salvation Army, Kiwanis, Salvation Army Auxiliary, Lulac, Center for Healthy Aging, and Conference of California Historical Societies. Gabriel is the author of two books on Santa Monica's history.

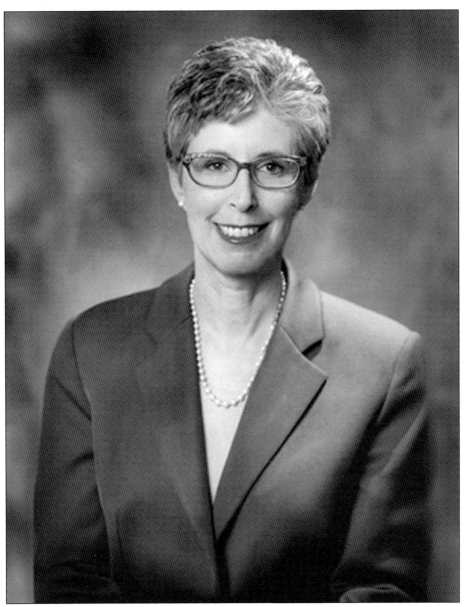

LOUISE JAFFE. Jaffe is an education advocate and resident of Santa Monica for over 20 years. She first became involved in community and education issues through her children, who were educated in Santa Monica public schools. She has been a PTA leader for more than 10 years, served two terms as president of the Will Rogers PTA, president of the Santa Monica Malibu Council of PTAs, and president of the Santa Monica High School PTSA. She has worked closely with PTA leaders from all Santa Monica and Malibu public schools. Jaffe has been repeatedly honored with PTA Honorary Service Awards and is the recipient of the PTA's highest award, the Golden Oak. In 1997, Jaffe helped create a shared community vision and led a focused and effective effort to realize Santa Monica's potential as a model Lifelong Learning Community. She is a well-known advocate for lifelong learning in Santa Monica, which has resulted in strong working relationships with community and organizational leaders throughout the city. In 2009, she served as president of the Santa Monica College Board of Trustees. (Courtesy Louise Jaffe.)

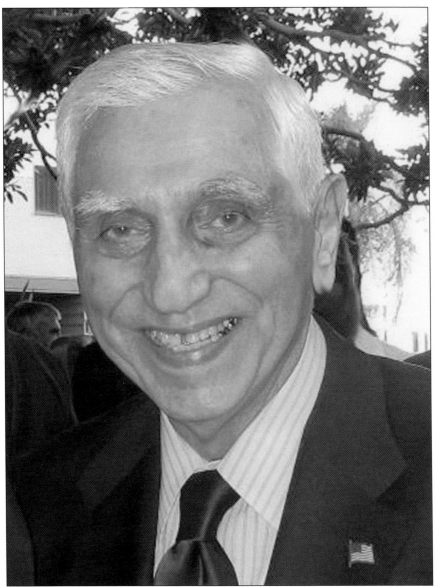

ROBERT M. "BOB" GABRIEL. Gabriel devoted most of his life to serving the community. Besides running the company he founded, Bob Gabriel Co. Insurance, he served as a city council member and chair of the Santa Monica Recreation and Parks Commission. He cofounded the Santa Monica History Museum with his wife, Louise, and has served as president of the Boys and Girls Club and chamber of commerce, was chairman of the Santa Monica Hospital Trustees and Santa Monica Convention & Visitors Bureau, a member of the Santa Monica College Advisory Board, and served on committees for the Santa Monica School District. He was a director of the Red Cross and area chairman for Danny Thomas's Capital Campaign to build St. Jude Hospital. Gabriel proudly served his country in World War II and the Korean Conflict. An icon in the community, he received numerous awards over the years, among them from the Boys Clubs of America, chamber of commerce, Lions Club, Kiwanis, Santa Monica Hospital Medical Center, Jaycees, Rotary International, Los Angeles County Board of Supervisors, Salvation Army, and a National Philanthropy Award.

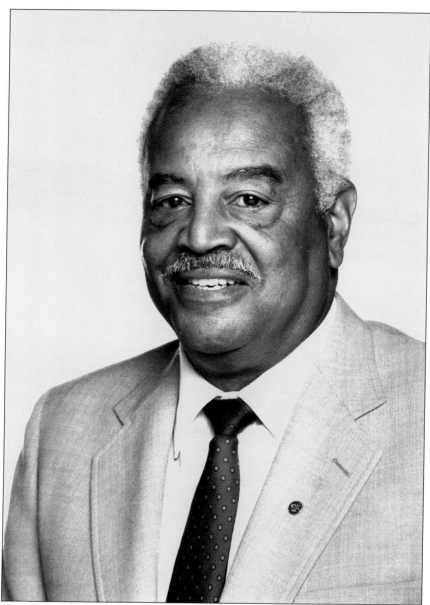

ALFRED THOMAS QUINN, EdD. Dr. Quinn's commitment to every area of his life made him a legacy. In World War II, he was one of the Tuskegee Airmen and attained the rank of staff sergeant. In 1951, Dr. Quinn was the first African American to be hired as a teacher in the Santa Monica Unified School District. He taught at Garfield Elementary and Lincoln Junior High and was a professor at Santa Monica College. After his retirement Dr. Quinn was elected to the college's board of trustees, later becoming chair. His legacy at the college is the annual Dr. Alfred T. Quinn Scholarship, established in 1988. In 1962, he was the first African American to be elected as the chair of the city's recreation commission. He served many community organizations, including the Boys Club, YMCA, and Rotary Club. His contributions and achievements were recognized by top-ranking public officials and service clubs. As a tribute to Dr. Quinn, the Quinn Research Center is dedicated to his philosophy of diversity and empowerment of the individual. (Courtesy Bruce Smith/Santa Monica College.)

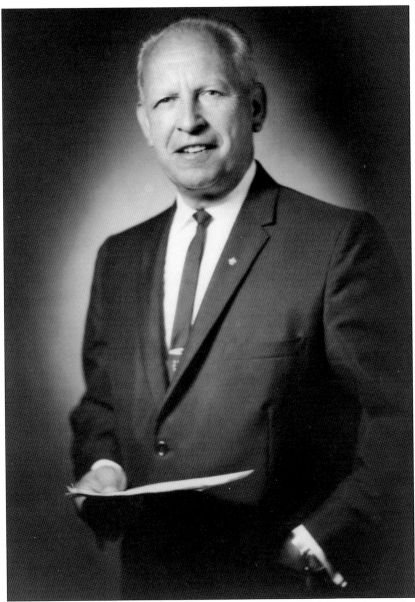

YSIDRO REYES. Reyes was a descendant of Ysidro Reyes, cograntee of Santa Monica Canyon. At the age of 21, he began working for Tod and Leslie Mortuary, attended the California College of Embalming, and graduated in 1936. During World War II, Reyes served in the Navy Medical Corps. In 1946, he founded the California Ambulance Company in Santa Monica. This included the first air ambulance service in the United States. He operated the Wilshire Funeral home from 1964 to 1980. Later, he was a director at Gates Kingsley & Gates, Moeller Murphy Funeral Homes. He served the community well and earned the moniker "Mr. Santa Monica." Reyes served as president of the Native Sons of the Golden West, the Exchange Club, and Kiwanis Club, was a Santa Monica History Museum founding member, executive director of the Crescent Bay Boy Scouts of America, and was active in the chamber of commerce and Red Cross. He helped found the Santa Monica Nativity Scenes in 1952. Reyes passed away on September 9, 2007. (Courtesy Sharon Reyes Siebufir.)

DR. ART VERGE. After receiving his doctorate from Oregon State University, Dr. Verge came to Santa Monica College as a counselor and professor of history. He was college registrar for many years. In the last few years, he has promoted overseas study abroad programs for the college. Dr. Verge has served as president of the Kiwanis Club, YMCA, Breakfast Club, and the CYO, and has served on the Santa Monica History Museum's Speakers' Bureau for many years. (Courtesy Dr. Art Verge.)

ROY E. NAYLOR. Naylor, founder of Naylor Paints, gave many years of service to the community. From 1925, he was actively involved in the chamber of commerce, was a former president of the Kiwanis Club and the YMCA, and served on the boards for the Salvation Army, Family Service, and Santa Monica College Advisory Board. In Naylor's memory, for his dedicated service, the chamber of commerce established the Roy E. Naylor Lifetime Achievement Award. Roy passed away in 2001. (Courtesy Santa Monica Chamber of Commerce.)

ALLAN YOUNG. In 1955, Allan Young's father brought him to the Boys Club. Membership was 50¢ a year. Young got his first job there. In 1963, he was named the Youth of the Year, and a parttime job went with the award. From there, he became assistant athletic director of the club. In 1966, he was drafted, went to the Naval Dental School, and served as dental tech in both Guam and Vietnam. When Young returned, he wanted to work at the Boys Club. By 1969, he was the club's athletic director. In 1977, he became the executive director. After many years, his title was changed to president/CEO. It was in 1990 that the Boys Clubs of America officially became the Boys and Girls Clubs of America. Young spent 32 years growing the club. In that time, he built 16 new clubs, mentored and trained 14 new club executive directors, and broadened youth leadership programs. Young won many awards for his work at the local, regional, and national levels. He retired in 2009 with many honors and accolades. (Courtesy Aaron Young.)

JEAN MCNEIL WYNER. In 1994, Jean joined Santa Monica Hospital as the physician-community liaison. In 1995, the hospital became Santa Monica UCLA Medical Center and Orthopædic Hospital, which believes in service to the community. Jean's dedicated services to the community are numerous. She was chairman of the boards of the Santa Monica History Museum, the Salvation Army Advisory Board, chamber of commerce, convention and visitors bureau, Westside Women's Health Center, and Santa Monica Pier Restoration Corporation. She is a past president of the YMCA, Santa Monica Breakfast Club, WISE Senior Services, and the Police Activities League; a member of the Rotary Club and Sister City, and serves on other boards. Among the service awards she has received are those from the YWCA, chamber of commerce, American Cancer Society, Center for Healthy Aging, Westside Challenge to beat Breast Cancer, and the Rotary Volunteer of the Year. (Courtesy Jean McNeil Wyner.)

CLYDE SMITH. Santa Monica community leader and political activist Clyde Smith passed away in 2009. Smith was the executive director of the Pico Neighborhood Redevelopment Corporation, a nonprofit organization that worked to rehabilitate hundreds of housing units in Santa Monica for elderly and low-income families. He served actively with the Rotary Club, Red Cross Chapter, Pico Neighborhood Association, Santa Monica Chamber of Commerce, and Santa Monica College Advisory Board. He chaired the Santa Monica Salvation Army Advisory Board and was a University of Southern California alumnus. (Courtesy Rosemary Smith.)

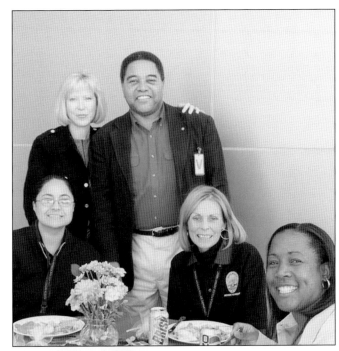

DONALD BRUNSON. Pictured are Donald Brunson and his wife, Edna. Donald is believed to be the first African American baby born in Santa Monica, in a house where Santa Monica High School now stands. Donald served as a postal letter carrier for 25 years. As a boy, he delivered orders from the Criterion Drugstore next to the Criterion Theater and made deliveries to notables such as Marion Davies and William Randolph Hearst. Donald and Edna were active in the community for many years. Donald was born in 1907.

RON AND ANN FUNK. Ann served as historical activities chairman for Santa Monica's Centennial Celebration in 1975, when the Santa Monica Historical Society was organized with her as its founding chairman. Over the years, she was actively involved in many community organizations. In 1956, Ron began working at the *Evening Outlook*, Santa Monica's first newspaper, and became editor/managing editor in 1970. During his tenure, he oversaw the publication in 1975 of a special centennial edition celebrating Santa Monica's 100th birthday. Ann and Ron have strongly supported the creation of the Santa Monica History Museum. They sponsored the museum's *Outlook* newspaper "In The Headlines" interactive exhibit, which allows a visitor's photograph to be superimposed on a reproduction of a front page of the past. (Courtesy Ann and Ron Funk.)

BILL BEEBE. Beebe, a prizewinning photographer, was born in West Los Angeles at a time when there were still vast areas of open land and wildlife, which have continued to be a source of inspiration to him today. At age nine, his family moved to Santa Monica where he attended grade and high school. In 1944, he joined the Navy, serving as a radar operator aboard the light cruiser *Boise* in the Pacific and Atlantic theaters. It was during a brief stop in France that he developed an interest in photography. In 1946, Beebe attended Santa Monica College and its companion technical school as a member of its first photographic class. In 1948, he went to work for Pacific Press Photos, a news agency covering the entire Westside. In 1950, he worked with the *Los Angeles Mirror*, which merged with the *Los Angeles Times* in 1960. In 1963, Beebe went to work at the *Evening Outlook* until he retired in 1993, after which he donated his collection of thousands of negatives to the Santa Monica History Museum. (Courtesy Bill Beebe.)

PHILA CALDWELL. Caldwell lived on Adelaide Drive in a landmark home built in 1911 by her grandparents. It was the third house constructed on that block, and Caldwell had visited the residence as a child. During World War II, she met her husband, George, while working as a volunteer air raid warden. They married in 1943 and purchased the Milbank house. The Caldwells started a silk screening business in the garage of their home that led to George Caldwell manufacturing one of the first microchips used in computers.

BOB PARNO HOLLIDAY. Holliday was co-valedictorian of the Santa Monica High School winter class of 1939 and attended UCLA and USC, where he graduated as a mechanical engineer. He served as copilot on a B-17, flying 30 missions over Germany in 1944–1945 and was awarded the Distinguished Flying Cross and the Air Medal with Four Clusters. Holliday spent 14 years as a research engineer at Rand Corporation. He was a founding member of the Samohi Alumni Association and was the editor of *Viking News* in its formative years. (Courtesy Darlyne Holliday.)

RICARDO BANDINI JOHNSON. Born in Santa Monica at St. John's Hospital, Johnson was raised and lived in the city until the 1990s, when he moved to Agoura Hills. His family has lived in California since 1810 and in Santa Monica from 1875. His great-aunt was Arcadia Bandini de Baker, the wife of the city's cofounder, Col. Robert S. Baker. Ricardo has been interested in Santa Monica and California history since 1956 and has been associated with the Santa Monica History Museum from its beginnings. He is the curator of the museum's J.P. Jones and Bandini Collection with over 50,000 photographs and records, which he helped catalog from 2004 to 2009 with a grant from the City of Santa Monica. He holds research cards at the Huntington Library, UCLA Research Center, National Archives in Washington, DC, and several other libraries. He has primarily worked on Santa Monica and California history for the past 35 years and is the research librarian for the Santa Monica History Museum's new state-of-the-art facility. (Courtesy Ricardo Bandini Johnson.)

Santa Monica Chamber of Commerce. The chamber, incorporated on May 20, 1925, plays an integral role in the community's economic prosperity and is a bridge that links the businesses, organizations, and residents together with innovative programs that strengthen long-term economic vitality, business success, job creation, and quality of life. It is the voice to city government on issues affecting its business members and works diligently to help them improve their bottom lines, enhance their credibility, and gain recognition in the community. The chamber advocates and represents business interests and issues affecting the community. It provides the environment to help its members prosper and succeed through a proactive working partnership with all levels of government and community organizations to achieve a healthy local economy and quality of life. The chamber is located at 1234 Sixth Street, Suite 100. Laurel Rosen is president and CEO. (Courtesy of Agnes Garcia.)

Eight
BUSINESSES BY THE BAY

READERS FINE JEWELERS. Readers Jewelers was established in Santa Monica over 70 years ago. It is currently a fifth-generation business. Eddie Guerboian acquired the store in 1978 and his wife, Evelyn, joined him in running the business in 1990. Eddie and Evelyn's son Avo, the sixth generation of Guerboian jewelers, also works at the store, which is located at 331 Wilshire Boulevard.

PATTON'S PHARMACY. The pharmacy is owned by Paul Leoni. In 1964, Pat Patton, the previous owner, renovated a coin-operated laundromat on the corner of Montana Avenue and Lincoln Boulevard and, with the talent of architect Jim Mount, transformed the eyesore into Patton's Pharmacy, one of the most attractive, prominent, and successful drugstores in Santa Monica. It is located at 734 Lincoln Boulevard.

RAND CORPORATION. Founded at the end of World War II, Rand was incorporated as a private, nonprofit California corporation in 1948. Although it has eight offices elsewhere in the United States and overseas, Santa Monica remains Rand's headquarters, with over 1,000 staff members housed in the new Lee Gold–certified facility at 1776 Main Street. Rand is engaged in research and analysis of matters affecting national security and the public interest. (Courtesy Agnes Garcia.)

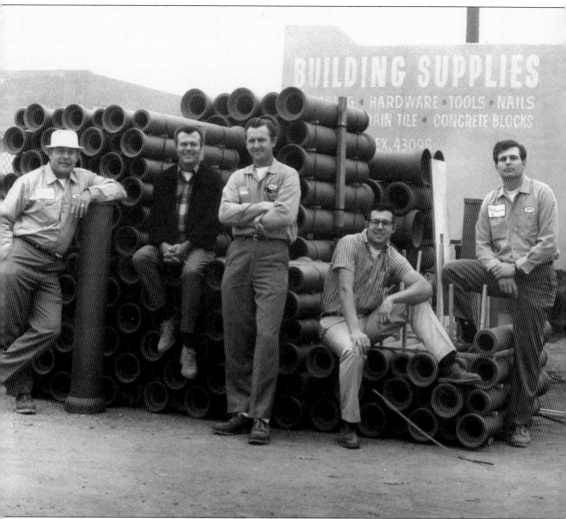

BOURGET BROS. BUILDING MATERIALS. In 1947, brothers Henry, Lawrence, and Leo Bourget bought a concrete manufacturing plant in Santa Monica and opened Bourget Concrete Products Co. with an initial investment of $300. In 1950, the brothers expanded their product line to include natural building stone, plumbing, masonry, and landscaping supplies as well as tools and hardware, changing the name to Bourget Bros. Building Materials. In 1964, Henry retired and sold his interest to younger brothers Leonard and John and brother-in-law Roy Kinslow. In 1984, the brothers purchased Coast Flagstone Co. in West Los Angeles, which they renamed Bourget Flagstone Co. and moved to Santa Monica. Leo retired in 1994, Lawrence passed away in March 2002, and Roy retired in 2004. In recent years, Bourget Bros. Building Materials has added a lumberyard and tile and pebble showrooms to offer a complete one-stop shop for its customers. In 2010, the company generously donated the stonework and installation throughout the Santa Monica History Museum's new state-of-the-art facility. From left to right are Leo Bourget, Larry Bourget, Roy Kinslow, Leonard Bourget, and John Bourget. (Courtesy Bourget Bros.)

Santa Monica Convention and Visitors Bureau. The bureau is a nonprofit organization comprised of travel counselors, administrative staff, and a board of community and business leaders. Its mission is to inform vacationers, explorers, and business travelers of all the benefits that Southern California travel has to offer and what makes Santa Monica the perfect vacation place with its beaches, award-winning restaurants, and accommodations. Misti Kerns is the president/CEO of the bureau, located at 1920 Main Street, Suite B. (Courtesy Agnes Garcia.)

HARDING LARMORE KUTCHER & KOZAL, LLP
ATTORNEYS AT LAW

Harding Larmore Kutcher & Kozal, LLP. This highly regarded full-service law firm serves a wide range of clients from its Santa Monica office. Each client receives individual attention with a level of expertise. In addition to performing work for nonprofits on a pro bono or reduced-fee basis, the attorneys are actively involved on boards of local civic and charitable organizations. The offices are located at 1250 Sixth Street, Suite 200. (Courtesy Harding Larmore Kutcher & Kozal.)

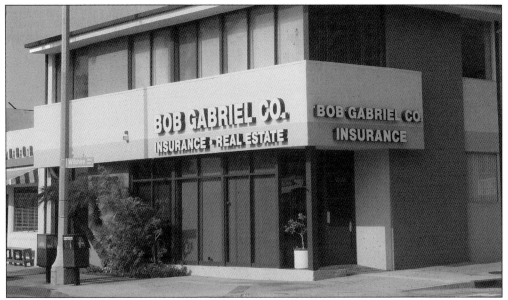

BOB GABRIEL CO. INSURANCE. In 1954, Gabriel became a partner in the Zydervelt Insurance Agency, which began in 1936. In 1957, he bought out the agency and renamed it Bob Gabriel Co. Insurance. His agency is widely recognized for its commitment to give outstanding customer service. Gabriel passed away in 2007, but the business remains family-owned and is operated by his daughter Susan Gabriel Potter and her husband, Pat Potter, who worked with Gabriel for over 25 years. The agency is located at 2325 Wilshire Boulevard. (Courtesy of Bob Gabriel Co. Insurance.)

MORLEY BUILDERS. Led by CEO Mark Benjamin, Morley Builders is co-owned by its nearly 200 employees. Morley Builders contracts its services through two wholly owned subsidiaries—Morley Construction Company and Benchmark Contractors, Inc. Its mission is to be an innovative and entrepreneurial company of individuals with integrity who work together to build quality projects with pride and dignity. Southern California has been its home since the company's founding in 1947. (Courtesy Tom Neary/Morley Builders.)

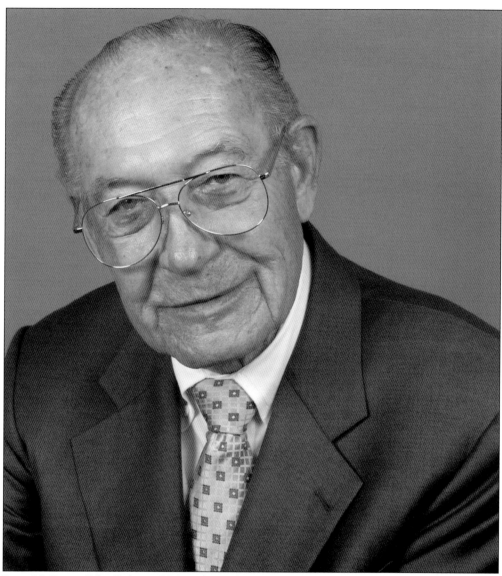

JOHN M. BOHN. John Bohn is CEO and president of The Bradmore Group. Prior to Pearl Harbor, John worked in flight test and aerodynamics on the experimental B-19 airplane as a Douglas employee at March Field in Riverside, California. During World War II, John was employed by Douglas Aircraft Company for the Army Air Corps secret Project 19 in Gura'e Eritrea, Africa. This project operated a complete aircraft factory in secrecy, which employed 2,500 American civilian aircraft workers to service British and American aircraft operating in Africa and the Middle East. Many of the Project 19 personnel were from Santa Monica. In 1949, John formed Tavco, Inc., which developed, manufactured, and sold proprietary aircraft equipment. Following that, John formed Bradmore Investment Company, Ltd., a factoring and commercial finance company. Tavco was later converted into a finance company. Over time, John established a series of companies now called The Bradmore Group, which owns and manages industrial and commercial property. John is a former city councilman and past chair of the Rotary Club and chamber of commerce; just a few of his many community involvements. (Courtesy Laurel Rosen/chamber of commerce.)

SOUTHERN CALIFORNIA DISPOSAL. Since 1913, Southern California Disposal and Recycling (SCD) has been a family-owned and -operated solid waste management enterprise. It began when Varus Kardashian began collecting garbage to be recycled as feed for the stock on his hog farm. His small enterprise grew and evolved until it became the company it is today, a forward-looking solid waste management business firmly rooted in the old-fashioned traditions of professionalism and customer service. Sam Kardashian now owns the company. (Courtesy Agnes Garcia.)

SOUTHERN CALIFORNIA DISPOSAL, AMERICAN FLAG. In 1974, SCD's founder Sam Kardashian wanted to declare his love for his country in a big way. He had a specially designed 100-foot tower constructed to display a 30-foot-by-50-foot American flag, which motorists can see driving down the 10 Freeway in Santa Monica. Each year, from Memorial Day through Independence Day, SCD displays a special POW-MIA flag to commemorate those missing from the Vietnam War. (Courtesy Agnes Garcia.)

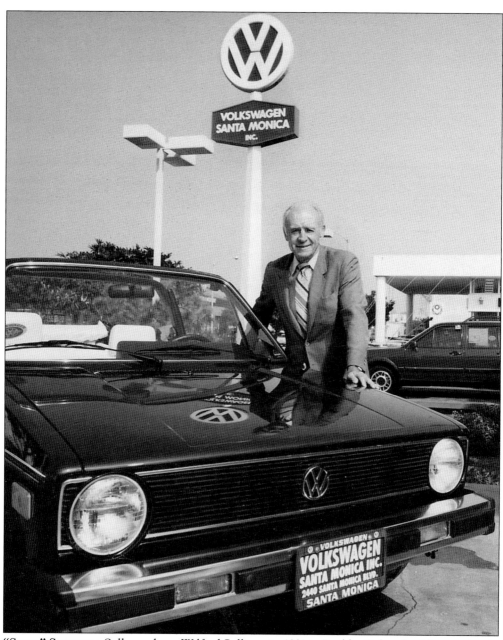

"Sully" Sullivan. Sully was born Wilfred Sullivan in 1921 in Pueblo, Colorado. After serving in the Air Force during World War II, he moved to Southern California where his entrepreneurial spirit led him to open his own used-car lot in Santa Monica and eventually his first Volkswagen dealership in Corona. In 1973, Sully purchased Volkswagen Santa Monica, which he ran successfully until his passing in 2002. A true innovator, Sully was one of the first in Los Angeles to open a Hyundai dealership, followed shortly by a new line for Toyota and Lexus. His love of people defined his contributions to the Santa Monica community, giving back to those who needed help the most in charities that focused on the family were always a priority and included the Boys and Girls Club, Big Brothers and Big Sisters, the Rotary Club, the Santa Monica Chamber of Commerce, and the Catholic Church. (Courtesy Mike Sullivan.)

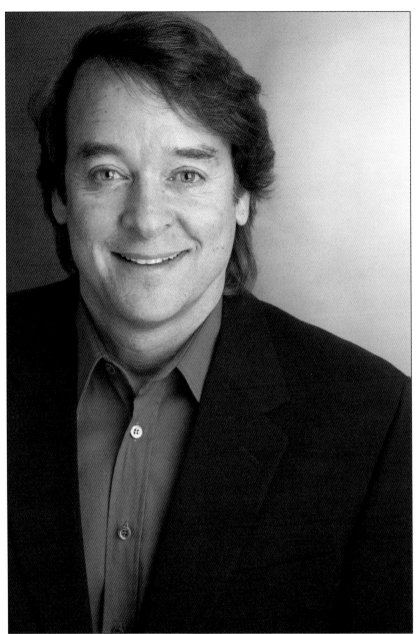

MIKE SULLIVAN. Sullivan is president and owner of Sullivan Automotive Group, the "LAcarGUY." His father, Sully, opened the family's first dealership in 1964. Mike followed his father into the family business and managed to build a chain of dealerships/franchises with annual sales of $600 million: Volkswagen Santa Monica, the flagship store (1984), Lexus Santa Monica (1989), Toyota of Hollywood/Scion Hollywood (1997), Pacific Porsche, Pacific Audi and Pacific Volkswagen (1999), and Toyota Santa Monica/Scion Santa Monica (2001). Sullivan plans to open one of 32 plug-in hybrid dealerships in Santa Monica featuring the Karma, a sedan that runs on electric motors powered by lithium batteries. He is passionate about giving back to the community and has been honored by Big Brothers, Big Sisters of Greater Los Angeles and Boys and Girls Club, to name a few. (Courtesy Mike Sullivan.)

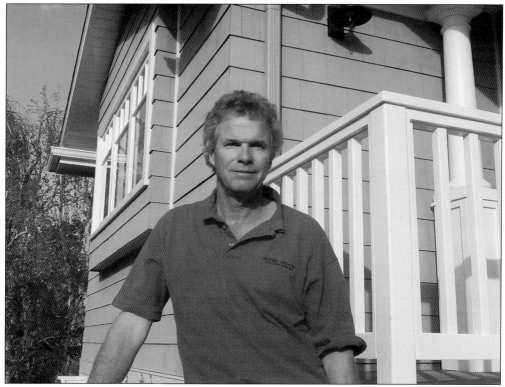

GLENN RICARD CONSTRUCTION. Ricard has been a general contractor in the Santa Monica and Westside area for over 30 years. He is a third-generation builder of fine homes and commercial properties and has left his mark on Santa Monica with numerous construction projects. Among his latest is the new Santa Monica History Museum. He is an active member in the community, serving on the boards of the Rotary Club and the Boys and Girls Club. (Courtesy Glenn Ricard.)

TEGNER-MILLER INSURANCE BROKERS. Started in 1901 by Charles Tegner, the real estate and insurance firm was joined by three of Tegner's four children during the 1920s. Tegner retired in 1929, and his son Carl became partners with Charles Spurgin and Ian Grant in what gradually evolved into solely an insurance business. Ken Miller is now principal and president, Dave Nelson is principal and chief operating officer, and Chris Czuzak is principal and secretary. The company is located at 2001 Wilshire Boulevard, Suite 101. (Courtesy Tegner-Miller Insurance.)

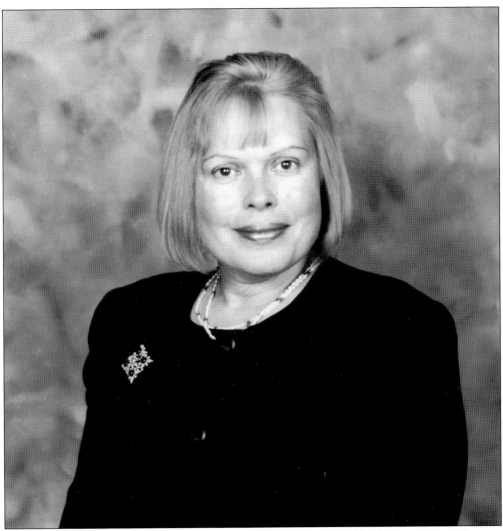

KRISTINA ANDRESEN, AIA. Andresen was the architect for the Santa Monica History Museum, DC-3 Monument Park, Santa Monica Ford Lincoln Mercury, and many other local projects. She studied at Ball State University, where she earned degrees in architecture and environmental design. After college, she moved to Florida and specialized in hospitals. Several years later, Andresen relocated to Beverly Hills, where she worked on major high-rise office buildings and condominiums. During the recession of 1982, she founded Andresen Associates Architects, and her first client was Lorimar Studios, which had eight hit shows on prime-time television. Andresen has had many high-profile clients, including MGM and Disney. She specializes in acoustic design, with many successful recording studios to her credit. Andresen is also an active community member on a number of boards, including Upward Bound House, Santa Monica College Board of Associates, Rotary Club, and Santa Monica Chamber of Commerce. She has received several prestigious community awards, including the YWCA Woman of the Year Award, the chamber's Roy E. Naylor Lifetime Achievement Award, and the Rotary Club Herb Spurgin Service Award. (Courtesy Kristina Andresen.)

SAINT JOHN'S HEALTH CENTER. Founded in 1942 by Sisters of Charity of Leavenworth, Saint John's Health Center provides Santa Monica, West Los Angeles, and the ocean communities with breakthrough medicine and inspired healing. The center, located at 1328 Twenty-second Street, was rebuilt with strong community support after sustaining severe damages in the 1994 earthquake. The new facility, completed in 2010, encompasses the state-of-the-art Howard Keck Diagnostic and Treatment Center and the Chan-Soon Shiong Center for Life Sciences (CSS). Built from the patient's perspective, the new Saint John's provides the latest in medical technology in a homelike environment without patients having to navigate the labyrinth of a typical large academic medical center. The two buildings that make up the new Saint John's Keck and CSS have a combined total of 236 private beds with the capability to expand to 268 beds. Saint John's provides a spectrum of treatment and diagnostic services with distinguished areas of excellence in cancer care, spine, orthopedics, women's health, cardiac care, and specialized programs such as the internationally acclaimed John Wayne Cancer Institute. (Courtesy Saint John's Health Center.)

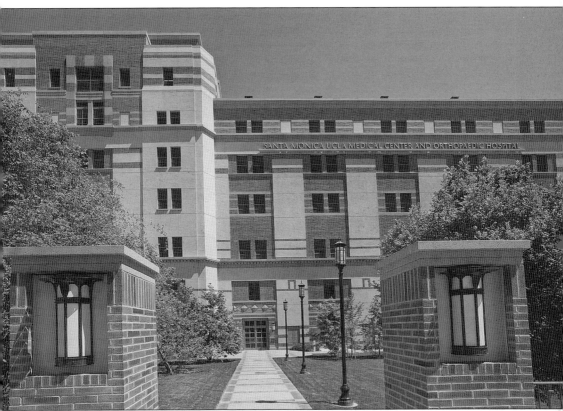

SANTA MONICA UCLA MEDICAL CENTER AND ORTHOPEDIC HOSPITAL. In 1926, the hospital opened on Sixteenth Street, and in 1943, it became the first to provide emergency services under contract with the City of Los Angeles. The Less Kelley Family Health Center was established in the 1940s. The hospital broke ground on an eight-story patient tower on Fifteenth Street in 1967 and when completed in 1971, the official bed count increased to 399. In 1969, the hospital dedicated the Nethercutt Emergency Center, and a rape treatment center opened in 1974. During the 1980s, the hospital was renamed Santa Monica Hospital Medical Center. It opened the city's first neonatal intensive care unit in 1985. (The current neonatal unit opened in 2008.) In 1984, the medical center broke ground on a $40-million building modernization program and, in 1988, opened the Merle Norman Pavilion. In 1995, Uni-Health America sold the medical center to the University of California Regents, and it was renamed Santa Monica UCLA Medical Center. The orthopedic hospital moved its inpatient services to Santa Monica, and in 2007, the hospital became the Santa Monica UCLA Medical Center and Orthopædic Hospital. (Courtesy Ted Braun.)

JAMES CAYTON. Cayton is the founder of Louver Drape and worked for several years to perfect the product. After he opened the door to his store on Fairfax Avenue in 1937, the company grew rapidly. In 1943, Cayton helped to organize the Venetian Blind Association of Southern California and became its first president. In 1971, Louver Drape broke ground on Eleventh Street in Santa Monica. By the 1980s, the Santa Monica headquarters had expanded to 500,000 square feet. Cayton retired in 1981. (Courtesy Santa Monica Chamber of Commerce.)

RICHARD LAWRENCE. Lawrence, a USC graduate, joined Santa Monica Bank as chief credit officer in 1982, following 20 years with United California Bank/First Interstate. In 1998, he joined First Private Bank, formerly Encino State Bank, where he served as regional manager of the Encino office. He has been president of the chamber of commerce, YMCA, Santa Monica College Associates, and the Rotary Club and has received service awards from the Center for Healthy Aging, Lions Club, and chamber of commerce. (Courtesy Richard Lawrence.)

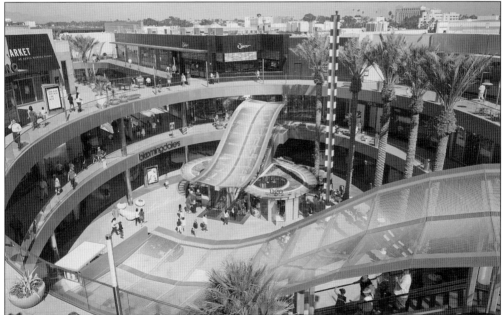

MACERICH SANTA MONICA PLACE. Macerich has been a part of Santa Monica for over 30 years. With its headquarters located here, it was exciting for the real estate company to have the opportunity to purchase Santa Monica Place and redevelop the property into an open-air retail and dining destination. After a $265-million renovation project, Santa Monica Place opened on August 6, 2010. The 550,000-square-foot center features over 50 shops and includes major retailers such as Nordstrom, Bloomingdale's, and Nike. (Courtesy Macerich Santa Monica Place.)

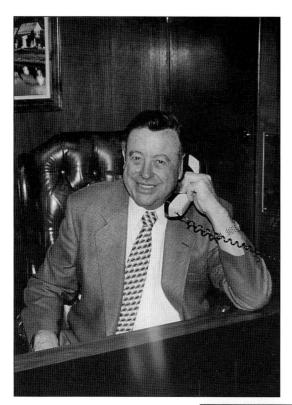

WAYNE HARDING. After graduating from Santa Monica High School, where he was class president, Harding went on to UCLA and played first base on the varsity baseball team. Following college, Harding got a job cleaning cars for a local automobile dealer. After working his way up into sales, he was able to buy into the Santa Monica Ford dealership. Harding spent 40 years at Santa Monica Ford and became chairman and CEO of the board. He has spent years helping the youth of the community. (Courtesy Chris Harding.)

WILLIAM S. MORTENSEN. In 1969, Mortensen was appointed president of First Federal Bank of California. He was elected chairman of the board in 1983. Mortensen's awards include many state and local honors. Both the California Assembly and Los Angeles County have recognized him for his civic activities. Mortensen was also honored by the Santa Monica–Malibu Board of Education for his contribution to public education by having the library at Santa Monica High School named for him.

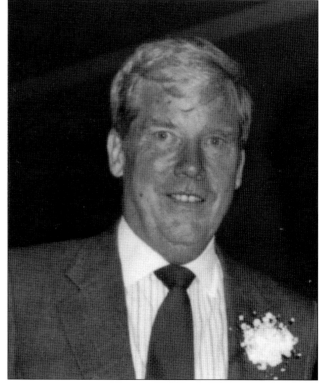

THE PHELPS GROUP. Associates at the Phelps Group operate in a full-feedback environment. Here, they are participating in an event called the Wall Banger. Work-in-progress from the client-based teams is displayed on the wall for feedback from the entire agency. Joe Phelps calls it "putting more brains on the business." Founded in 1981 by Phelps and located at 901 Wilshire Boulevard, the Phelps Group is a fully integrated marketing communications company. The agency is recognized as an innovator in a field where businesses innovate for a living. The company's key strengths include brand-building retail expertise, travel, upscale brands and markets, health care, financial services, restaurants, and packaged goods. Service offerings include general market and Hispanic expertise in integrated marketing communications consisting of advertising, public relations, and promotions delivered across broadcast, print, and digital platforms. The services are delivered by multidiscipline, client-based teams. Clients include Capitol Source Bank, City of Hope, Goodwill Industries, Panasonic, Public Storage, Tahiti tourism, Whole Foods Market, and United Healthcare. (Courtesy the Phelps Group.)

FISHER HARDWARE & LUMBER. Formerly located at Fourteenth Street and Colorado Avenue, the company was founded in 1923 by John Fisher and George Swartz. Bob Sievers started working at Fisher in 1948 and became a business partner with Joe Cleary. In 1980, the property was sold to Weyerhaeuser Corporation. The property was sold to the City of Santa Monica in 2004. Fisher Hardware & Lumber reopened in 2006 at 1600 Lincoln Boulevard.

WHITE SUTTON & COMPANY INSURANCE SERVICES. Ernie White founded the business in 1952 and formed a partnership with Gerald McNees and Charles Dunbar around 1965. A decade later, White's sons Dennis and Daryl joined the agency. In the early 1980s, Dennis became president of the company and is now chairman of the board. His partner, Michael Sutton, is vice chairman of the board. Andrew Valdivia is chief executive officer. The company is located at 807 Arizona Avenue.

JAMES MOUNT, AIA. Mount arrived in Santa Monica shortly after World War II. He studied architecture at the University of Southern California and went to work for several well-known architectural firms before he opened his own office in 1958. During more than 50 years of continuous practice, he produced many buildings and added to and remodeled countless others. Mount designed the Red Cross Building, the Salvation Army Church and headquarters, Memorial Park Gymnasium, the former Fisher Lumber Co. building, and the YWCA building. He had a part in the design of almost all of the auto dealerships in Santa Monica, including W.I. Simonson Mercedes Benz after its building was destroyed by fire. His many community activities include serving as president of the YMCA, chamber of commerce, Sunrise Optimist Club, and Community Chest (now known as the United Way). He has been on the boards of the Red Cross, YWCA, and the advisory board of Community Corporation of Santa Monica. (Courtesy Red Cross.)

NAYLOR'S PAINTS. One of the longtime businesses in Santa Monica is Naylor's Paints. It was established in 1962 by Roy Naylor, a well-known and respected community leader. The store calls itself "the second happiest place on earth." It serves homeowners and contractors and offers friendly and expert advice. Naylor's son Larry has been running the business at 132 Lincoln Boulevard since his father's demise. Roy Naylor passed away in 2001.

BARRETT'S APPLIANCES. Starting in 1946, Laurence "Pete" Barrett slowly built up his appliance repair business on Main Street in Santa Monica, at first taking the bus to service calls until he saved up enough money for a truck. Pete quickly built up the enterprise. In 1985, after 40 years on Main Street, his son Pat took over and moved the business to 2723 Lincoln Boulevard.

BAY AREA NEWSPAPERS. The first newspaper in Santa Monica was the *Outlook*, published in 1875 by L.T. Fisher; it ceased publication on March 14, 1998. The *Argonaut* was founded in 1971 by David Asper Johnson. The *Santa Monica Star* was established in 1984 by Diane Margolin. David Ganezer began the *Santa Monica Observer* in 1998. The *Santa Monica Daily Press* was founded on November 13, 2001, by Ross Furukawa, Dave Danforth, and Carolyn Sackariason.

FRED SEGAL. Many years ago, Segal had an idea about fashion. He believed that people should be able to dress in a relaxed casual manner and that their clothing should reflect their personalities. In the 1960s, Segal set the idea into motion with a vision of jeans in the way they are seen today: indigo-dyed, studded, embellished, and high fashion. Celebrities such as Jennifer Aniston, Brad Pitt, and Britney Spears shop at the store, located at 500 Broadway.

BUBAR'S JEWELERS. Since 1945, Bubar's Jewelers has served customers. The business began as a small store on Santa Monica Boulevard where employees from the local railroad and bus company came in for watch inspections. Growing as Santa Monica expanded, Bubar's relocated to Third Street, then to Santa Monica Place Mall. Eventually, it moved to its present location at 1457 Fourth Street. Nat and Gertrude Bubar began Bubar's Jewelers legacy. (Courtesy Agnes Gomez.)

BOULEVARD CAMERA. The shop was originally opened in 1946 by Herb Goldsworthy. With partner Ed Tynan, Bud Gallagher came in 1957 and bought out Goldsworthy. They sold televisions and stereos in the mid-1970s. In 1980, J.P. Gallagher acquired his father's stake, and Rod Rodriguez bought out Ed Tynan in 1986. That same year, they put in a lab to develop prints in-house and opened a studio to do portraits, headshots for actors, and passport photographs and since have added a digital lab that scans prints.

BOB'S MARKET. Bob Rosenbloom started working in his father's store in Venice in 1940 and opened his own grocery store in 1965. He found the property at 1650 Ocean Park Boulevard, and it became the first Bob's Market. Over the years, he added stores and then sold them off as big chains started to consolidate smaller rivals. There are people who have been coming to this friendly neighborhood store since they were children. It offers flexibility and custom orders. (Courtesy Agnes Garcia.)

LOUIS T. BUSCH. Busch followed the real estate business in Santa Monica from 1921, when he and Julius Ange established the first realty office on Wilshire Boulevard, called Bargain Realty Company. This business continued for five years until the partnership was ended. Busch then opened his own office at the corner of Ocean Avenue and Pico Boulevard. He subsequently moved to Twenty-sixth Street and Wilshire Boulevard. He was one of the first to specialize in Santa Monica property. (Courtesy Louis Busch Jr.)

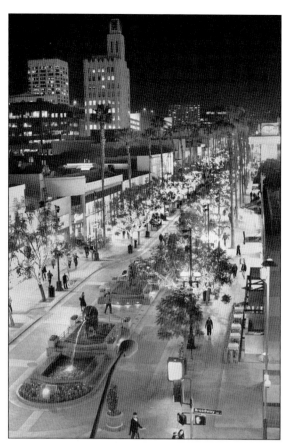

BAYSIDE DISTRICT CORPORATION. Founded in 1994, Bayside District is responsible for managing and promoting the continued revitalization of downtown Santa Monica, as well as programs, projects, and services that benefit the community. There are 30 blocks in downtown Santa Monica, from Ocean Avenue to Seventh Court Alley and Wilshire Boulevard to Interstate 405, and it includes the world-famous Third Street Promenade in the image at left. Kathleen Rawson is the executive director of Bayside District. (Courtesy Bayside District Corporation.)

BIG BLUE BUS. In September 2009, Santa Monica's Big Blue Bus dedicated its new maintenance facility, which replaced a 40-year-old facility. The new facility, with 201 buses, operates 24 hours a day, 365 days a year.

Nine
Santa Monica, a Beautiful City

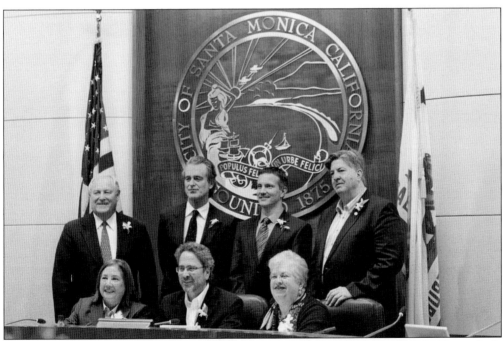

CITY OF SANTA MONICA. Once pastureland, today Santa Monica is a city with 90,000 people. It was founded in 1875 by Col. Robert S. Baker and Sen. John P. Jones. On July 10, 1875, a map of Santa Monica was recorded in the office of the Los Angeles County recorder. In 1946, a council-city manager form of government was adopted. The year 2010 marked the city's 135th anniversary. City council members shown here include, from left to right, (first row) Gleam Davis, Mayor Richard Bloom, and Pam O'Connor; (second row) Dr. Bob Holbrook, Bobby Shriver, Terry O'Day, and Kevin McKeown. The city hall is located at 1685 Main Street. (Courtesy Rob Schwicker/*Daily Press*.)

SANTA MONICA VETERANS MEMORIAL. The city installed a veterans memorial in Palisades Park honoring those who served in the armed forces. The public was invited to the dedication held on November 11, 1999. The monument of eight tall granite columns representing each branch of the United States Armed Forces is designed to cast shadows across a new pathway in Palisades Park every year on the 11th day of the 11th month at 11:00 a.m. (Courtesy Barbara Stinchfield/City of Santa Monica.)

SANTA MONICA MAIN LIBRARY. In 2006, actress and author Jamie Lee Curtis opened the daylong celebration of the newly built library, located at 601 Santa Monica Boulevard. An estimated 5,000 people attended the celebration. The first floor contains the fiction library collection, the 146-seat Martin Luther King Jr. Library, and Friends of the Library used bookstore. Its courtyard has the Bookmark Café. Greg Mullen is the head librarian. (Courtesy Cynni Murphy/Santa Monica Public Library.)

PALISADES PARK. Atop the palisades bluffs, Palisades Park, a historical treasure, provides spectacular views of the coastline, Santa Monica Bay, and the Santa Monica Mountains. In 1897, Arcadia Bandini de Baker, wife of Santa Monica cofounder Col. Robert S. Baker, and Sen. John P. Jones, the other Santa Monica cofounder, donated a parcel of land to the city to be used forever as a park for the people. In 1915, the park's original name, Linda Vista, was changed to Palisades Park. It has always been a center of activities. Among the many points of interest in the park are the Statue of St. Monica, the Will Rogers Monument erected in 1952 to commemorate Roger's many contributions to his country, a camera obscura (a forerunner of the modern camera) built in 1889 and moved to the park from north beach in the early 1900s, and the Senior Recreation Building, built of Palos Verdes stone.

WOODLAWN CEMETERY. Prior to 1870 when it started, the cemetery was originally known as Ballona Township Cemetery. Arcadia Bandini de Baker and Sen. John P. Jones were equal owners of the property. In 1907, the graveyard was deeded to the City of Santa Monica by Senator Jones and Arcadia de Baker through Judge J.J. Carrillo, who had her power of attorney. The cemetery was nine acres in size but grew to 28 acres. A mausoleum was built in 1928 and was purchased by the city in 1976. The cemetery contains the remains of many well-known persons, such as early Spanish families the Machados, Higueras, Lugos, and Talamantes; the Vawter family, who founded the First Presbyterian Church in Santa Monica; Abbot Kinney, founder of Venice; and Hollywood celebrities, including Leo Carrillo, Irene Ryan, and Doug McClure.

ALYS DROBNICK. History was made in Santa Monica when Drobnick became the first woman on the city council. She served from 1957 to 1961. Prior to that, she was on the city's recreation commission. Drobnick inspired others, for she always stood up for what she believed was best for the community and made time to support many community organizations, such as the Red Cross, YMCA, and Salvation Army. In the photograph above are, from left to right, (seated) Drobnick; (standing) unidentified, Ysidro Reyes, and Louise Gabriel, president of the Santa Monica History Museum.

ROD GOULD, CITY MANAGER. In 2009, Gould was elected city manager by the Santa Monica City Council to replace Lamont Ewell, who retired. Gould had served as the city manager of Poway, California. He has a degree in economics and political science from Yale and earned a master's degree in education and public administration from Harvard. In past years, Gould had served as city manager of both San Rafael and Monrovia. (Courtesy City of Santa Monica.)

JAMES T. BUTTS JR. Butts is a former Santa Monica chief of police. He was sworn in to this post in September 1991, served for 15 years, and was applauded by the city for his exemplary service. This photograph was taken when he was Santa Monica police chief, acknowledging appreciation from the 22nd block club for his efforts to step up bike patrols in the neighborhood. In 2006, Butts was sworn in as deputy executive director of law enforcement at Los Angeles World Airports, where he served until 2009.

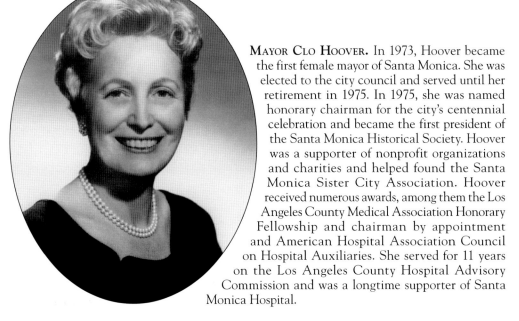

MAYOR CLO HOOVER. In 1973, Hoover became the first female mayor of Santa Monica. She was elected to the city council and served until her retirement in 1975. In 1975, she was named honorary chairman for the city's centennial celebration and became the first president of the Santa Monica Historical Society. Hoover was a supporter of nonprofit organizations and charities and helped found the Santa Monica Sister City Association. Hoover received numerous awards, among them the Los Angeles County Medical Association Honorary Fellowship and chairman by appointment and American Hospital Association Council on Hospital Auxiliaries. She served for 11 years on the Los Angeles County Hospital Advisory Commission and was a longtime supporter of Santa Monica Hospital.

PUBLIC SAFETY FACILITY. The city's new 118,000-square-foot facility, built in 2003 and located at 333 Olympic Drive, is home to the Santa Monica Police Department, administrative offices of the Santa Monica Fire Department, and a City Emergency Operations Center. In addition, the four-story building houses a jail. (Courtesy Santa Monica Police Department.)

SANTA MONICA POLICE ACTIVITIES LEAGUE (PAL). A citywide program especially for kids, PAL offers free educational, cultural, and athletic activities for boys and girls ages six to 17 who are Santa Monica residents or go to schools in Santa Monica. PAL fosters trust between youth and the men and women of the Santa Monica Police Department in a safe and nurturing environment. Its facility is located at 1401 Olympic Boulevard.

TIMOTHY JACKMAN, POLICE CHIEF. In December 2006, Jackman began serving as Santa Monica police chief. He took over that position from former chief James Butts. Jackman has had 23 years of law enforcement service with the Long Beach Police Department and was deputy chief of the Investigative Bureau. His primary goal is to help bring the city to its lowest crime rate and to keep it a safe place to live. (Courtesy City of Santa Monica.)

SCOTT FERGUSON, FIRE CHIEF. Formerly fire chief of Manhattan Beach, Ferguson replaced Santa Monica's chief Jim Hone, who retired after many years of service. Ferguson's experience throughout his career is a benefit to the city. Before becoming fire chief of Manhattan Beach, Ferguson was a chief officer of two growing agencies in Peoria, Arizona, and Vancouver, Washington. He received a master's degree in management from Wayland Baptist University in Phoenix, Arizona. (Courtesy Brandon Wise/Daily Press.)

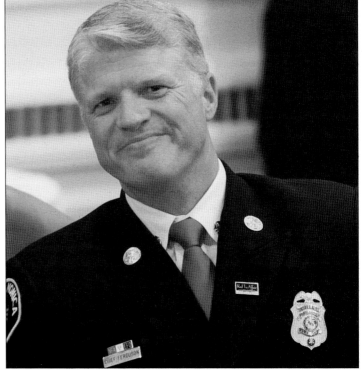

GEORGE WELLER ACCIDENT. On July 16, 2003, Weller drove his Buick Le Sabre into the busy downtown Farmer's Market in Santa Monica. The 86-year-old driver killed 10 people and injured 63. In the wake of numerous civil lawsuits filed against the City of Santa Monica and the company organizing the Farmer's Market, a new policy was adopted requiring portable concrete barricades to block vehicle access to pedestrian street events. (Courtesy Rob Schwicker/*Daily Press*.)

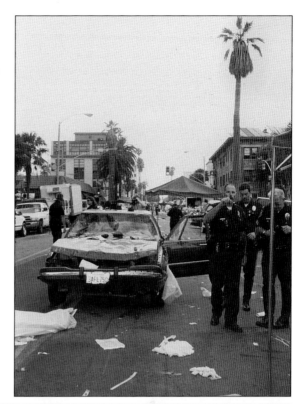

COUNTY BUILDING. Located at 1725 Main Street, the building is located between the city hall and the Civic Auditorium. It contains courtrooms and county offices. The original 1956 structure has since been added on to and remodeled. Among the many high profile cases held there have been actress Judy Garland's divorce and O.J. Simpson's 1995 trial, pictured here.

INDEX

Andresen, Kristina, 17, 103
Angels Attic Museum, 20
Annenberg Beach Club, 14
Arcadia Bandini Monument, 13
Assistance League, 74
Barnum Hall, 21
Baron's Castle, The, 15
Billingsley, Barbara, 42
Bayside District Corp., 116
Barrett's Appliances, 112
Beebe, Bill, 89
Big Blue Bus, 116
Bison Archives, 6, 41, 43– 45
Bob Burns Restaurant, 30
Bob Gabriel Co. Insurance, 81, 97
Bob's Market, 115
Boelsems, Paula, 60
Bohn, John, 98
Border Grill, 24
Boulevard Camera, 114
Bourget Bros., 95
Braun, Ted, 63, 105
Bresnik, Albert, 57, 59
Bresnik, Randy, 57
Broad Stage, 20
Brunson, Donald, 87
Bubar's Jewelers, 114
Bundy, May Sutton, 7, 53
Busch, Louis T., 115
Butts, James, 122, 124
Bicentennial of Flight, 52
Bay Area Newspapers, 113
Caldwell, Phila, 90
Calif. Heritage Museum, 14
Calvary Baptist Church, 39
Carlthorp School, 70
Casa Del Mar, 7, 37

Cayton, James, 106
Champagne Towers, 7, 32
Chez Jay, 28
Chinois, 8, 23
Chrysalis, 72
Cirque du Soleil, 8, 18
City of Santa Monica, 13, 14, 47, 48, 53, 62, 64, 73, 76, 79, 91, 110, 117, 118, 121, 124, 125
County Building, 125
Currey, Carole, 78
DC-3 Monument, 17, 103
Dellinger, Dorothy, 54
Dellinger, Kip, 54
Dixon, Tom, 56
Doolittle, James, 52, 54
Drobnick, Alys, 121
Earhart, Amelia, 57, 59
Edwards, Stephanie, 46
El Cholo Restaurant, 24
Employees Commun. Fund, 75
Enterprise Fish Co., 28
Fairmont Miramar Hotel, 7, 33
Family Service, 69, 78, 84
Ferguson, Scott, 124
Fisher Hardware and Lumber, 110
Freeman, Izzy, 26
Funk, Ron and Ann, 88
George Weller Accident, 125
Gabriel, Louise, 49, 52, 67, 79
Gabriel, Robert, 4, 67, 81, 97
Galley Restaurant, 22
Gehry, Frank, 8, 58
Georgian Hotel, 36
Ghurabi, Wally, 63
Gilmore, John, 62
Gould, Rod, 121
Grable, Betty, 8, 41

Grayson, Kathryn, 8, 44
Glenn Ricard Construction, 102
Hagman, Larry, 43
Harding Lamore Kutcher & Kozal, 96
Harding, Chris, 108
Harding, Wayne, 108
Harris, Jim, 49
Heal the Bay, 10, 65
Herrera, Kevin, 40
Hill, Phil, 58
Holliday, Bob, 90
Holliday, Darlyne, 90
Hoover, Clo, 12, 53, 73, 122
Izzy's Deli, 26
Jackman, Timothy, 124
Jaffe, Louise, 80
Johnson, Ricardo Bandini, 91
Jaycees, 70, 81
LaBorde, Mae, 48
Lawrence, Richard, 107
Leone, Billie, 15, 50
Leone, Baron, 15, 50
Lobster Restaurant, 29
Lockhart, June, 44
Loews Santa Monica Beach Hotel, 8, 36
Louise's Trattoria, 25
Lawrence Welk Plaza, 32
Macdonald-Wright, Stanton, 64
Macerich Santa Monica Place, 107
McKenzie, Rena, 46, 58
Merle Norman Pavilion, 105
Michael's Restaurant, 27
Morley Builders, 11, 17, 97
Mortensen, William, 108

Mount, James, 61, 94, 111
Museum of Flying, 16, 62
Mount Olive Church, 40
Murphy, Cinni, 64, 118
Naylor, Roy, 69, 84, 103, 112
Naylor Paints, 84, 112
Neary, Tom, 97
Nethercutt, J.B., 56
Nethercutt Emergency Center, 63, 105
Norman, Merle, 56
Northridge Earthquake, 8, 21, 38, 63, 104
Oceana Hotel, 35
Public Safety Facility, 123
Pacific Dining Car, 29
Pacific Park Santa Monica Pier, 10
Palisades Park, 13, 19, 67, 118, 119
Patton, Gen. George S., 28
Patton's Pharmacy, 94
Phelps Group, The, 109
Pilgrim Church, 38
Powell, Mary Ann, 10
Price, David, 17, 62
Puck, Wolfgang, 8, 23
Quinn, Alfred, 82
Rand Corporation, 7, 90, 94
Rapp Saloon, 12
Readers Fine Jewelers, 93
Regalbuto, Joe, 43
Reagan, Ronald, 40, 54
Rehwald, Mary, 61
Reyes, Ysidro, 19, 83
Ride, Sally, 55
Rosen, Laurel, 6, 92, 98
Salvation Army Auxiliary, 46, 75, 79
Santa Monica Airport, 16, 17, 52, 62
Santa Monica Bay Woman's Club, 67, 71, 79
Santa Monica Birthday Celebrations, 8, 48, 49, 51
Santa Monica Breakfast Club, 74, 84, 86
Santa Monica Centennial, 8, 49, 53, 88, 122
Santa Monica Chamber of Commerce, 6, 7, 19, 47, 53, 79, 81, 83, 84, 86, 87, 92, 98, 100, 103, 106, 107, 111

Santa Monica College, 7, 19, 20, 55, 68, 76, 78, 79, 80, 81, 82, 83, 84, 87, 89, 103, 107
Santa Monica Conservancy, 72
Santa Monica Convention & Visitors Bureau, 81, 86, 96
Santa Monica Daily Press, 6, 40, 113, 117, 124, 125
Santa Monica High School, 7, 21, 48, 57, 64, 68, 80, 87, 89, 90, 108
Santa Monica High School Alumni Association (Samohi), 58
Santa Monica History Museum, 2, 4, 6–8, 11, 13, 28, 45, 50, 51–53, 61, 67, 77–79, 81, 83, 84, 86, 88, 89, 91, 95, 102
Santa Monica History Museum Tours, 11
Santa Monica Public Library, 64, 118
Santa Monica Museum of Art, 12
Santa Monica Nativity Scenes, 19, 83
Santa Monica Pier, 2, 7, 8, 10, 18, 22, 29, 49, 65, 77
Santa Monica Pier Aquarium, 10
Santa Monica Pier Carousel, 9, 77
Santa Monica Pier Centennial, 49
Santa Monica Pier Restoration Corporation, 6, 10, 49, 86
Santa Monica Playhouse, 18
Santa Monica Police Activities League, 86, 123
Santa Monica Police Department, 51, 63, 123
Santa Monica Seafood, 22
Santa Monica Shores, 34
Santa Monica Sister City, 73, 76, 86, 122
Santa Monica Symphony, 15
Santa Monica Veterans Memorial, 118
Santa Monica UCLA Medical Center, 63, 86, 105
Santa Monica YMCA, 66, 82, 84, 86, 107, 111, 121
Santa Monica YWCA, 66, 79, 86, 103, 111
Schwarzenegger, Arnold, 47, 76
Schwicker, Rob, 117, 125
Segal, Fred, 113
Shangri-La, Hotel, 35
Sheraton Delfina Hotel, 37
Siebufir, Sharon Reyes, 83
Smith, Clyde, 87
Smith, Rosemary, 87
Southern Calif. Disposal, 99
Southern Calif. Disposal, American Flag, 99
Spurgin, Caroline Tegner, 78
Spurgin, Herb, 12, 19, 103
Spurgin, Virginia Tegner, 78
Stan Laurel Centennial, 8, 50
Stuart, Gloria, 48, 49
St. Anne's Catholic Church, 42
Stinchfield, Barbara, 118
Saint John's Health Center, 91, 104
Sullivan, Mike, 101
Sullivan, Wilfred "Sully," 100, 101
Sykes, Jubilant, 46
Tegner Miller Insurance, 102
Trinity Baptist Church, 39
Valentino, 25
Verge, Art, 84
Viceroy Hotel, 34
Victorian, The, 27
Waldron, D'Lynn, 15
Wanamaker, Marc, 6, 41, 43–45
Welk, Lawrence, 8, 31, 32, 48, 53
Weller, George, 125
White Sutton & Company Insurance Services, 110
White, Monika, 73, 76
Whiting, Jane Newcomb, 77
Whiting, Kathy, 77
Wilshire Palisades Building, 31
Wise, Brandon, 124
Woodlawn Cemetery, 120
Wu, Sylvia, 30
Wyner, Jean McNeil, 86
Young, Aaron, 85
Young, Allan, 85
Zucky's Delicatessen, 26

www.arcadiapublishing.com

Discover books about the town where you grew up, the cities where your friends and families live, the town where your parents met, or even that retirement spot you've been dreaming about. Our Web site provides history lovers with exclusive deals, advanced notification about new titles, e-mail alerts of author events, and much more.

Arcadia Publishing, the leading local history publisher in the United States, is committed to making history accessible and meaningful through publishing books that celebrate and preserve the heritage of America's people and places. Consistent with our mission to preserve history on a local level, this book was printed in South Carolina on American-made paper and manufactured entirely in the United States.

This book carries the accredited Forest Stewardship Council (FSC) label and is printed on 100 percent FSC-certified paper. Products carrying the FSC label are independently certified to assure consumers that they come from forests that are managed to meet the social, economic, and ecological needs of present and future generations.

Cert no. SW-COC-001530
www.fsc.org
© 1996 Forest Stewardship Council

Find Your Place in History.